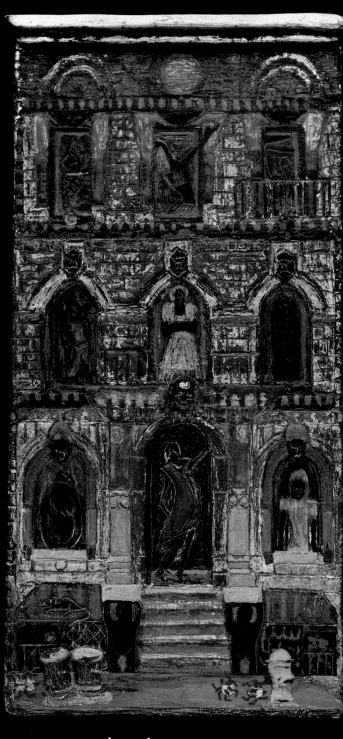

Now we, brethren, as Isaac was,
are the children of promise.

— GALATIANS 4:28

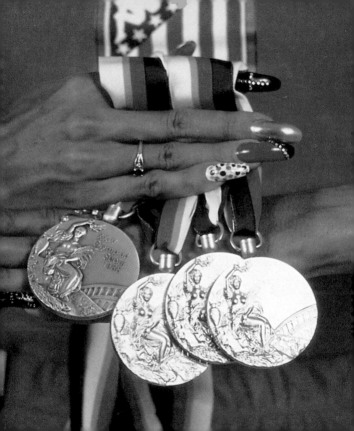

CHILDREN OF PROMISE

African-American Literature
and Art for Young People

EDITED BY CHARLES SULLIVAN

HARRY N. ABRAMS, INC., PUBLISHERS, NEW YORK

THIS BOOK IS DEDICATED TO THE LITERARY FRIENDS
OF THE MARTIN LUTHER KING MEMORIAL LIBRARY, WASHINGTON, D.C.,
FOR SHARING THEIR WRITINGS
AND FOR ENCOURAGING OTHERS TO EXPRESS THEMSELVES
FREELY

EDITOR: MARGARET RENNOLDS CHACE

DESIGNER: CAROL ANN ROBSON

RIGHTS AND PHOTO RESEARCH: NEIL RYDER HOOS

Library of Congress Cataloging-in-Publication Data

Children of promise: African-American literature and art for young
 people/edited by Charles Sullivan.
 p. cm.
 Summary: Poems, prose, photographs, and paintings explore the
 African-American experience as seen through art and literature by
 blacks or about black subjects.
 ISBN 0–8109–3170–2
 1. Afro-Americans—Literary collections. 2. Children's
 literature, American—Afro-American authors. [1. Afro-Americans—
 Literary collections. 2. American literature—Afro-American
 authors—Collections. 3. Art appreciation.] I. Sullivan, Charles,
 1933–
 PZ5.C43546 1991
 700'.89'96073—dc20 91–7566
 CIP

Published in 1991 by Harry N. Abrams, Incorporated, New York
A Times Mirror Company

Printed and bound in Hong Kong

On page 1:
Welcome to My Ghetto Land, Jean Lacy, 1986

On page 2:
*Hands of Florence Griffith Joyner Holding Her
Four Olympic Medals*, photograph by Steve
Powell, 1988

FOREWORD

On December 30, 1799, seventy-three free men of color presented a petition to the president and the U.S. Congress. In retrospect their request seems eminently reasonable: "If the Bill of Rights or the Declaration of Congress are of any validity, we beseech that as we are men, we may be admitted therein." In asking for inclusion, those free men of color were urging the new democracy to set out in the direction of perfection. They were asking for the full realization of an ideal exquisitely set forth in the Declaration of Independence, the Constitution, the Bill of Rights — the blueprints of the country. The request of those free men of color was, of course, denied. Democracy, in practice, was imperfect. For two hundred years the country has grappled with the imperfect practice of democracy and its promise. For two hundred years the confrontation between the real and the ideal has resonated through every level of American culture. It is in the language of our laws, the images of our poetry and painting, the conscience of our prophets and presidents.

Charles Sullivan's anthology *Children of Promise* lets us hear the voices, voices from the American past — Black and White — who bear the evidence of a country striving toward the reconciliation between the real and the ideal. The petition of the free men of color is one such fragment. There are the words of presidents. In correspondence between Thomas Jefferson and Benjamin Banneker, Banneker counsels Jefferson to "wean himself from . . . narrow prejudices." One hundred fifty years later, Truman's executive order integrating the armed forces reminds us how long the narrow prejudice lingered. There are the visionary words of our poets and philosophers, Walt Whitman, W. E. B. Du Bois, Robert Lowell, Martin Luther King, Jr., Gwendolyn Brooks, Imamu Amiri Baraka. There are the popular stereotypes, the darkies and "masses" of Stephen Foster's "My Old Kentucky Home" or Thomas Eakins' *Dancing Boy*, the bent, effacing images shuffling around in our past. There are the quiet first-person observations: Frederick Douglass describing his life in slavery, James Baldwin describing Harlem. Most exhilarating, however, is the language of promise. When Langston Hughes writes of "our temples for tomorrow" or when Robert Hayden speaks of celebrating the life of Douglass, the life of the slave who reinvented himself, " . . . with the lives grown out of his life, the lives/fleshing his dream of the beautiful, needful thing," they remind us that as we strive toward that perfection, we are all children of promise.

Mary Schmidt Campbell
Commissioner of Cultural Affairs, New York City

BUILDING

GWENDOLYN BROOKS

When I see a brave building
straining high, and higher,
hard and bright and sassy in the seasons,
I think of the hands that put that strength together.

The little soft hands. Hands coming away from cold
to take a challenge and to mold this definition.

Amazingly, men and women
worked with design and judgment, steel and glass,
to enact this announcement.
Here it stands.

Who can construct such miracle can enact
any consolidation, any fusion.
All little people opening out of themselves,

forging the human spirit that can outwit
big Building boasting in the cityworld.

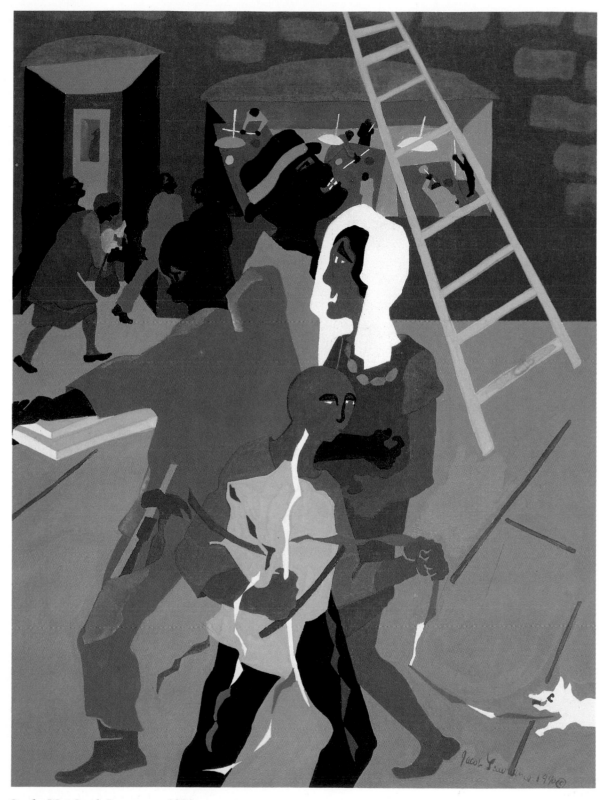

On the Way, Jacob Lawrence, 1990
Commissioned by the Smithsonian Institution, Washington, D.C.

TEMPLE FOR TOMORROW

from THE NEGRO ARTIST AND THE RACIAL MOUNTAIN

LANGSTON HUGHES

We younger Negro artists who create now intend to express our individual dark-skinned selves without fear or shame. If white people are pleased we are glad. If they are not, it doesn't matter. We know we are beautiful. And ugly too. The tom-tom cries and the tom-tom laughs. If colored people are pleased we are glad. If they are not, their displeasure doesn't matter either. We build our temples for tomorrow, strong as we know how, and we stand on top of the mountain, free within ourselves.

Self-Portrait, Jacob Lawrence, 1977

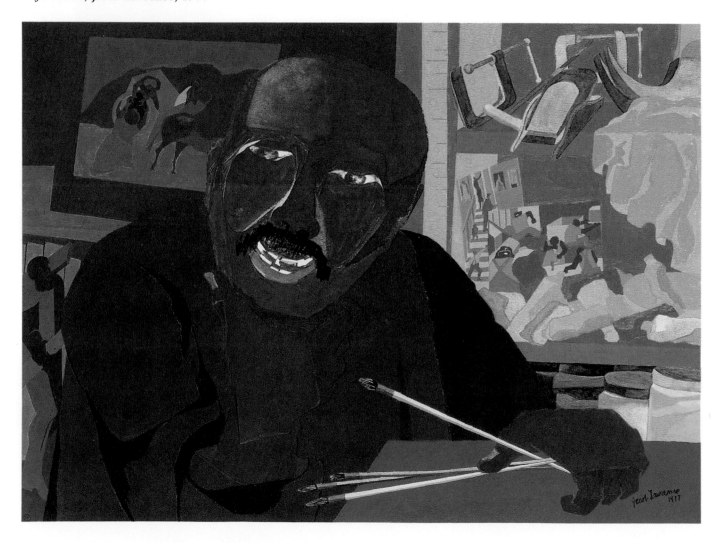

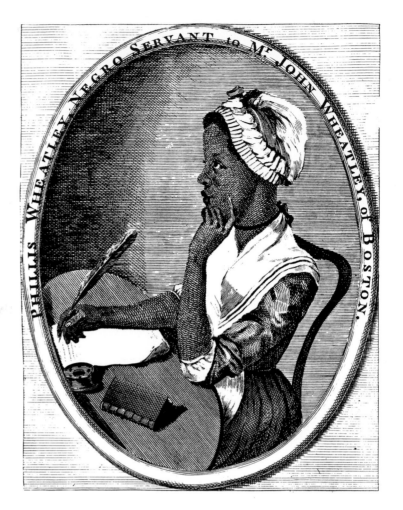

Phillis Wheatley, as shown in her book,
Poems on Various Subjects, Religious and Moral, 1773

One of many slaves who gained freedom and
became successful in the American colonies.

ON BEING BROUGHT FROM AFRICA TO AMERICA

PHILLIS WHEATLEY

'Twas mercy brought me from my *Pagan* land,
Taught my benighted soul to understand
That there's a God, that there's a *Saviour* too:
Once I redemption neither sought nor knew.
Some view our race with scornful eye,
"Their color is a diabolic die."
Remember, Christians, Negroes, black as Cain,
May be refined, and join th' angelic train.

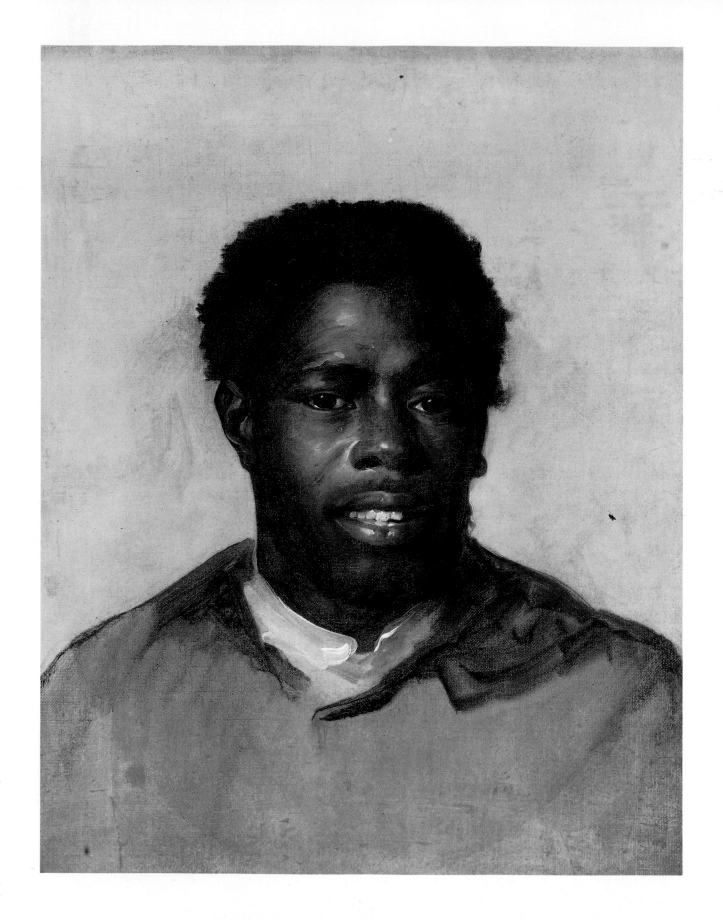

YOUNG SOUL

IMAMU AMIRI BARAKA (LEROI JONES)

First, feel, then feel, then
read, or read, then feel, then
fall, or stand, where you
already are. Think
of your self, and the other
selves... think
of your parents, your mothers
and sisters, your bentslick
father, then feel, or
fall, on your knees
if nothing else will move you,

 then read
 and look deeply
 into all matters
 come close to you
 city boys —
 country men

 Make some muscle
 in your head, but
 use the muscle
 in yr heart

Head of a Negro, John Singleton Copley, 1777–78

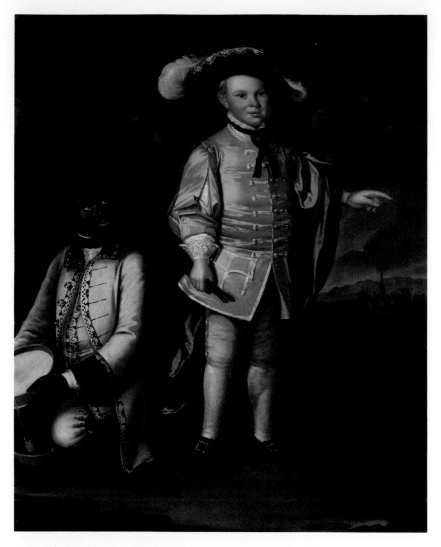

Portrait of John Calvert and Negro Page, John Hesselius, 1761
Master and servant in the British colony of Maryland.

I HAVE HAD TWO MASTERS

from NARRATIVE OF THE LIFE OF FREDERICK DOUGLASS, AN AFRICAN SLAVE, WRITTEN BY HIMSELF, 1845

FREDERICK DOUGLASS

I have had two masters. My first master's name was Anthony. I do not remember
his first name. He was generally called Captain Anthony—a title which,
I presume, he acquired by sailing a craft on the Chesapeake Bay.
He was not considered a rich slaveholder. He owned two or three farms,
and about thirty slaves. His farms and slaves were under the care of an overseer.

NOCTURNE OF THE WHARVES

ARNA BONTEMPS

All night they whine upon their ropes and boom
against the dock with helpless prows:
these little ships that are too worn for sailing
front the wharf but do not rest at all.
Tugging at the dim gray wharf they think
no doubt of China and of bright Bombay,
and they remember islands of the East,
Formosa and the mountains of Japan.
They think of cities ruined by the sea
and they are restless, sleeping at the wharf.

Tugging at the dim gray wharf they think
no less of Africa. An east wind blows

and salt spray sweeps the unattended decks.
Shouts of dead men break upon the night.
The captain calls his crew and they respond—
the little ships are dreaming—land is near.
But mist comes up to dim the copper coast,
mist dissembles images of the trees.
The captain and his men alike are lost
and their shouts go down in the rising sound of waves.

Ah little ships, I know your weariness!
I know the sea-green shadows of your dream.
For I have loved the cities of the sea,
and desolations of the old days I
have loved: I was a wanderer like you
and I have broken down before the wind.

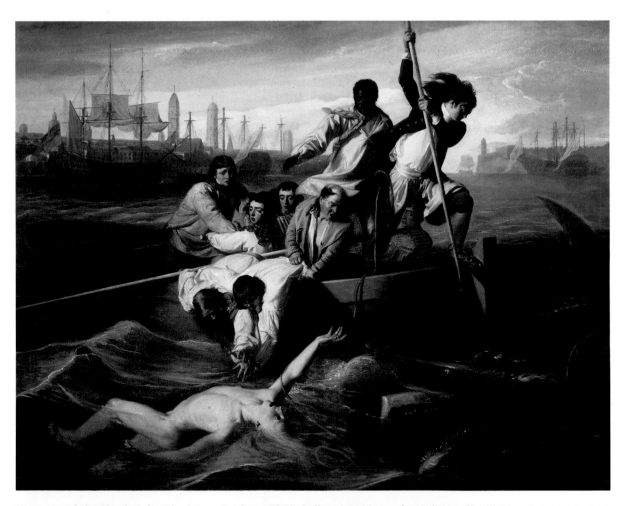

Watson and the Shark, John Singleton Copley, 1778 Sailors rescuing a drowning man.

Lieutenant Grosvenor and Peter Salem
(detail from *The Battle of Bunker Hill*),
John Trumbull, 1786

Salem, a hero of the American Revolution,
helped to win the Battle of Bunker Hill
by shooting a British officer.

THE ENLISTMENT OF FREE BLACKS AS CONTINENTAL SOLDIERS IN MASSACHUSETTS

from a letter to John Adams, October 24, 1775, from Brigadier General John Thomas

I am sorry to hear that any prejudice should take place in any of the southern colonies with respect to the troops raised in this; I am certain the insinuations you mention are injurious; if we consider with what precipitation we were obliged to collect an army. The regiments at Roxbury, the privates are equal to any that I served with in the last war, very few old men, and in the ranks are few boys, our fifers are many of them boys, we have some Negroes, but I look on them in general equally serviceable with other men, for fatigue and in action.

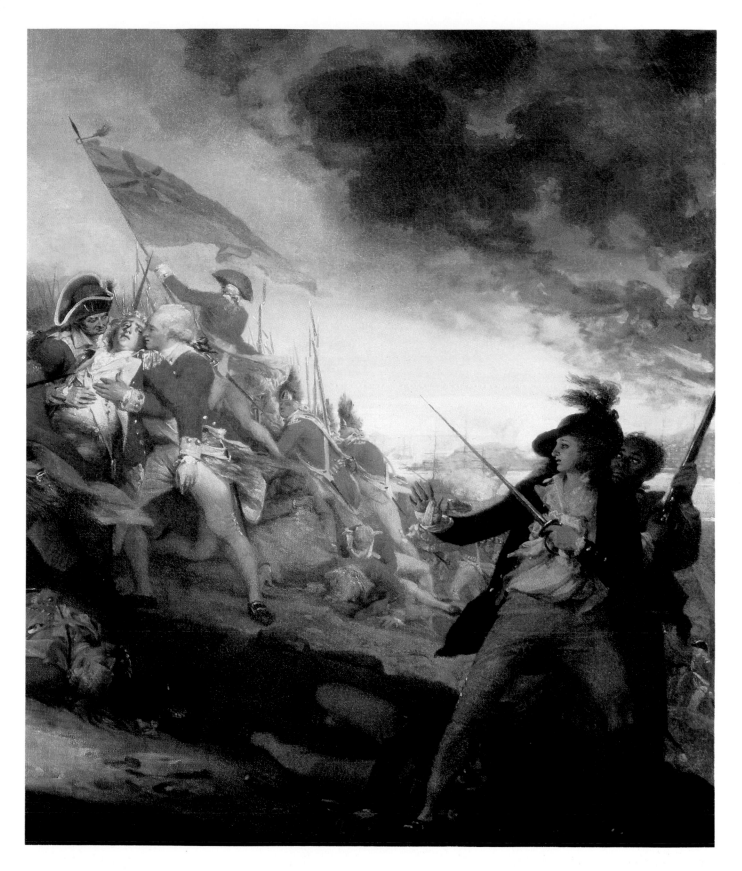

15

INTEGRATION OF THE ARMED SERVICES OF THE UNITED STATES

from Executive Order 9981, July 26, 1948, by President Harry S Truman

It is hereby declared to be the policy of the president that there shall be equality
of treatment and opportunity for all persons in the armed services without regard to
race, color, religion or national origin. This policy shall be put into effect
as rapidly as possible, having due regard to the time required to effectuate
any necessary changes without impairing efficiency or morale.

the white troops had their orders but the Negroes looked like men

Excerpt from poem

GWENDOLYN BROOKS

They had supposed their formula was fixed.
They had obeyed instructions to devise
A type of cold, a type of hooded gaze.
But when the Negroes came they were perplexed.
These Negroes looked like men.

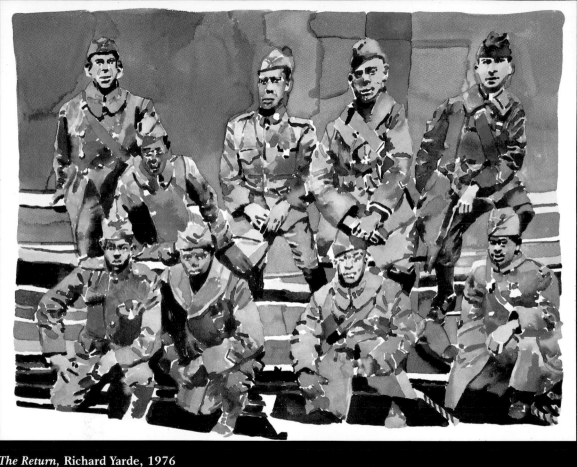

The Return, Richard Yarde, 1976

Although they served their country well, African Americans were not fully integrated into the armed forces of the United States until 1948.

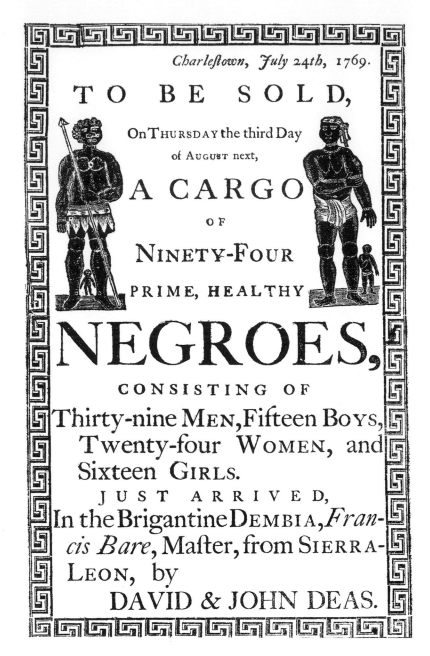

To Be Sold, public notice for a sale of slaves, 18th century

Slavery, started by the British government in 1627, continued after the American colonies had won their independence.

THE PRICE OF A SLAVE IN CAROLINA

from THE INTERESTING NARRATIVE OF THE LIFE OF OLAUDAH EQUIANO, OR GUSTAVUS VASSA, THE AFRICAN, WRITTEN BY HIMSELF, 1814

GUSTAVUS VASSA

About the latter end of the year 1764, my master bought a larger sloop, called the Prudence, about seventy or eighty tons, of which my captain had the command. I went with him into this vessel, and we took a load of new slaves for Georgia and Charles Town.

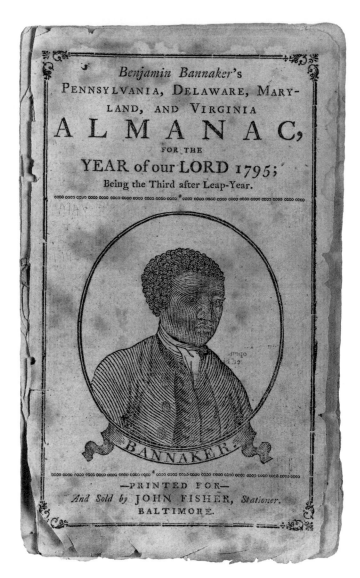

Benjamin Banneker, as shown on the title page of his *Almanac,* 1795

His name is now usually spelled "Banneker"; he challenged Jefferson's views on equality, freedom, and slavery.

BANNEKER TO JEFFERSON

from a letter to Thomas Jefferson, August 19, 1791, from Benjamin Banneker

Sir, I suppose that your knowledge of the situation of my brethren is too extensive to need a recital here; neither shall I presume to prescribe methods by which they may be relieved, otherwise than by recommending to you, and all others, to wean yourselves from those narrow prejudices which you have imbibed with respect to them, and as Job proposed to his friends "Put your Souls in their Souls' stead," thus shall your hearts be enlarged with kindness and benevolence towards them, and thus shall you need neither the direction of myself or others in what manner to proceed herein.

JEFFERSON TO BANNEKER

from a letter to Benjamin Banneker, August 30, 1791, from Thomas Jefferson

Sir, I thank you sincerely for your letter of the 19th instant and for the Almanac it contained. No body wishes more than I do to see such proofs as you exhibit, that nature has given to our black brethren, talents equal to those of the other colors of men, and that the appearance of a want of them is owing merely to the degraded condition of their existence, both in Africa and America.

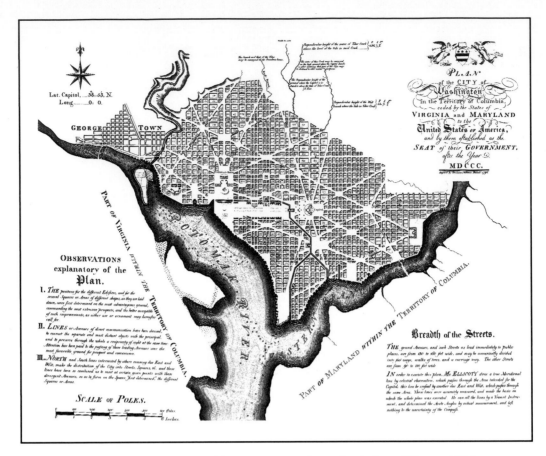

Pierre-Charles L'Enfant's Plan of Washington, D.C., as drawn by Andrew Ellicott, 1792
Banneker did many of the measurements and calculations on which this plan is based.

JEFFERSON TO CONDORCET

from a letter to the Marquis de Condorcet, Secretary of the Academy of Sciences
in Paris, August 30, 1791, from Thomas Jefferson

I am happy to be able to inform you that we have now in the United States
a negro, the son of a black man born in Africa, and a black woman born
in the United States, who is a very respectable mathematician. I procured
him to be employed under one of our chief directors in laying out the
new federal city of the Potowmac, & in the intervals of his leisure,
while on that work, he made an Almanac for the next year, which he sent
me in his own handwriting, & which I inclose to you. I have seen very
elegant solutions of Geometrical problems by him. Add to this that he is a
very worthy & respectable member of society. He is a free man. I shall be
delighted to see these instances of moral eminence so multiplied as
to prove that the want of talents observed in them is merely the effect of
their degraded condition, and not proceeding from any difference in
the structure of the parts in which intellect depends.

OLD MASTER JEFFERSON

from MEMOIRS OF A MONTICELLO SLAVE, 1847, as dictated to Charles Campbell by Isaac

Mr. Jefferson always singing when ridin' or walkin'; hardly see him anywhar outdoors but what he was a-singin'. Had a fine clear voice; sung minnits (minuets) and sich; fiddled in the parlor. Old Master very kind to servants.

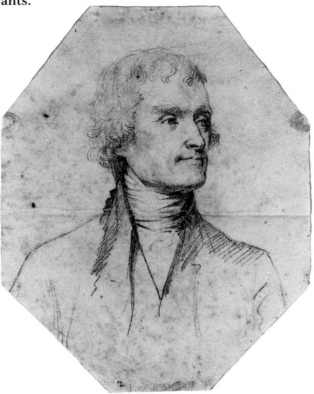

Thomas Jefferson, Benjamin Henry Latrobe, about 1799

He struggled with the question but kept some slaves until the day he died.

GOOD AND FAITHFUL SERVANTS

from the will of Thomas Jefferson, March 17, 1826

I give to my good, affectionate, and faithful servant Burwell his freedom, and the sum of three hundred Dollars to buy neccssarics to commcncc his trade of painter and glazier, or to use otherwise as he pleases. I give also to my good servants John Hemings and Joe Fosset, their freedom at the end of one year after my death: and to each of them respectively all the tools of their respective shops or callings: and it is my will that a comfortable log-house be built for each of the three servants so emancipated on some part of my lands convenient to them with respect to the residence of their wives, and to Charlottesville and the University, where they will be mostly employed, and reasonably convenient also to the interests of the proprietor of the lands; of which houses I give the use of one, with a curtilage of an acre to each, during his life or personal occupation thereof.

Philadelphia 30th of December 1799 —

John his + Smith mark

Parker his X Harris mark

John his + Mang mark

David his + Jackson mark

Thomas his + Caulker mark

Joseph Houston Alexander mark

Bartlet his + Kinney mark

James his X Brown mark

William his + Squire mark

Adam his + James mark

Henry + Williams mark

Thomas Farmer

Lot Rasine

Isaac his + Williams mark

Jacob his + Gibbs mark

Severn his + Custer mark

James Wilson

Benjamin his + Jackson mark

William his + Coulson mark

Richard Allen

Job his + Albert mark

Samuel his + Wilson mark

John his + Nelson mark

Thomas his + Walton mark

Edward his + Matthews mark

Anthony his + Williams mark

John his + Harris mark

Philip his + Johnson mark

Edward + Simon

Charles his + Caldwell mark

Pettigrew

Ishmael his + Robinson mark

Joseph Conway

Wiley + Cottahs

Nathan his + Jones mark

John his + Jackson mark

Abraham Depee

James his + Scotton mark

Prince his + Sprience mark

Henry his + Peters mark

Adam his + Leff mark

John his + Hall mark

John his + Whittier mark

exe Jacob Jones

John his + Jones mark

Charles Johnson

Stephen Saers

Robert Williams

William Whitt

Stephen Miller

Cyrus Porter

Jacob Nicholson

Alexr Weathered

Nathan Gray

Chols Ivy

Thomas his + Allen mark

Liam his + Brown mark

his + Riley mark

Charles his + Boston mark

Jacob his + Lancaster mark

Quomony Clarkson

Thomas his + Mattis mark

Robert Green

James his X Bowen mark

John his + Black mark

Peter his + Matthews mark

John his + Smith mark

John his + Morris mark

Philip his + Wills mark

Ignatius Cooper mark

Cato Collins

STOP THE AFRICAN SLAVE TRADE

from the petition of Absalom Jones and 73 others, December 30, 1799

TO THE PRESIDENT, SENATE, AND HOUSE OF REPRESENTATIVES.

The Petition of the People of Colour, free men, within the City and Suburbs
of Philadelphia, humbly showeth....

In the Constitution and the Fugitive Bill, no mention is made of black people,
or slaves: therefore, if the Bill of Rights, or the Declaration of Congress
are of any validity, we beseech, that as we are men, we may be admitted
to partake of the liberties and unalienable rights therein held forth;
firmly believing that the extending of justice and equity to all classes
would be a means of drawing down the blessing of Heaven upon this land,
for the peace and prosperity of which, and the real happiness of every
member of the community, we fervently pray.

Petition to Stop the African Slave Trade, December 30, 1799

Signatures of African-American citizens, including Absalom Jones
and Richard Allen, who petitioned the government
of the United States.

A

THANKSGIVING SERMON,

PREACHED JANUARY 1, 1808,

In St. Thomas's, or the African Episcopal, Church,
Philadelphia:

ON ACCOUNT OF

THE ABOLITION

OF THE

AFRICAN SLAVE TRADE.

ON THAT DAY,

BY THE CONGRESS OF THE UNITED STATES

BY ABSALOM JONES,
RECTOR OF THE SAID CHURCH.

———

PHILADELPHIA:
PRINTED FOR THE USE OF THE CONGREGATION.
FRY AND KAMMERER, PRINTERS.
1808.

A Thanksgiving Sermon on Account of the Abolition
of the African Slave Trade, by Absalom Jones,
January 1, 1808

After years of effort, Jones and the others succeeded
in persuading the president and Congress
to end the slave trade.

FREEMEN OF THE LORD

from A THANKSGIVING SERMON ON ACCOUNT
OF THE ABOLITION OF THE AFRICAN SLAVE TRADE,
January 1, 1808

ABSALOM JONES

Let the first of January, the day of the abolition of the slave trade in our country, be set apart in every year, as a day of publick thanksgiving for that mercy. Let the history of the sufferings of our brethren, and of their deliverance, descend by this means to our children to the remotest generations; and when they shall ask, in time to come, saying, What mean the lessons, the psalms, the prayers and the praises in the worship of this day? let us answer them, by saying, the Lord, on the day of which this is the anniversary, abolished the trade which dragged your fathers from their native country, and sold them as bondmen in the United States of America.

THE TURNING POINT

from NARRATIVE OF THE LIFE OF FREDERICK DOUGLASS, AN AFRICAN SLAVE, WRITTEN BY HIMSELF, 1845

FREDERICK DOUGLASS

This battle with Mr. Covey was the turning point in my career as a slave. It rekindled the few expiring embers of freedom and revived within me a sense of my own manhood. It recalled the departed self-confidence and inspired me again with a determination to be free. The gratification afforded by the triumph was a full compensation for whatever else might follow, even death itself. He can only understand the deep satisfaction which I experienced, who has himself repelled by force the bloody arm of slavery. I felt as I never felt before. It was a glorious resurrection, from the tomb of slavery to the heaven of freedom. My long-crushed spirit rose, cowardice departed, bold defiance took its place; and I now resolved that, however long I might remain a slave in form, the day had passed forever when I could be a slave in fact.

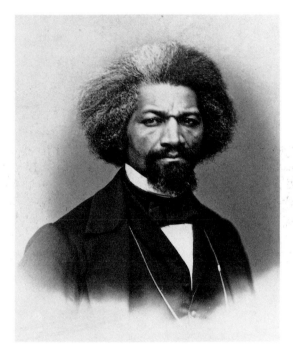

Frederick Douglass, photograph by J. W. Hurn, about 1860

The end of the slave trade did not mean the end of slavery in this country. Douglass escaped in 1838 and became a famous antislavery speaker and writer.

THIS MAN, THIS DOUGLASS

from FREDERICK DOUGLASS

ROBERT HAYDEN

This man, this Douglass, this former slave, this Negro
beaten to his knees, exiled, visioning a world
where none is lonely, none hunted, alien,
this man, superb in love and logic, this man
shall be remembered. Oh, not with statues' rhetoric,
not with legends and poems and wreaths of bronze alone,
but with the lives grown out of his life, the lives
fleshing his dream of the beautiful, needful thing.

TO CINQUE

Excerpt from poem

JAMES M. WHITFIELD

All hail! thou truly noble chief,
 Who scorned to live a cowering slave;
Thy name shall stand on history's leaf,
 Amid the mighty and the brave.

NO MORE AUCTION BLOCK

SPIRITUAL

No more auction block for me,
No more, no more,
No more auction block for me,
Many thousand gone.

No more peck of corn for me,
No more, no more,
No more peck of corn for me,
Many thousand gone.

No more pint of salt for me,
No more, no more,
No more pint of salt for me,
Many thousand gone.

No more driver's lash for me,
No more, no more,
No more driver's lash for me,
Many thousand gone.

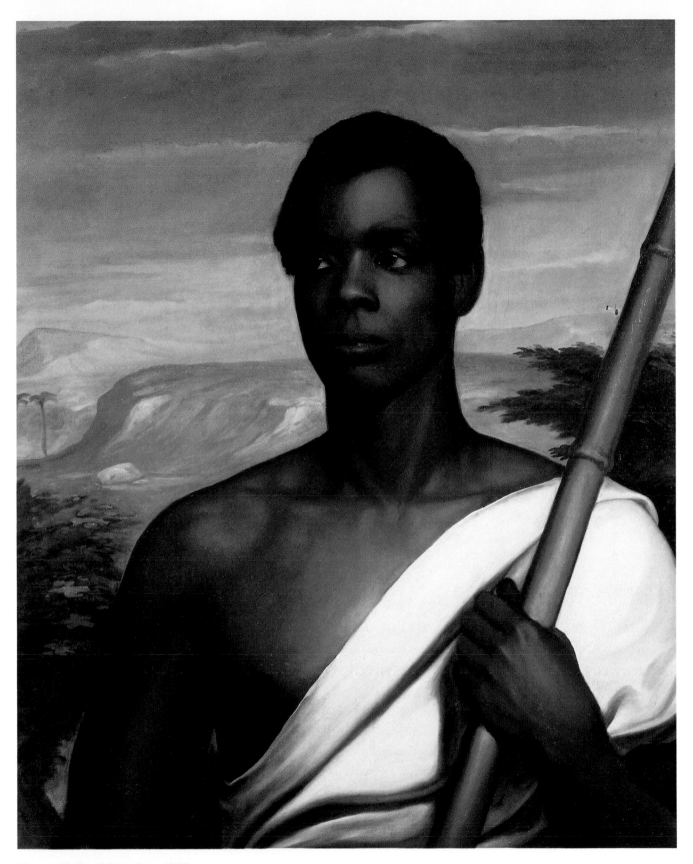

Cinque, Nathaniel Jocelyn, 1839

Leader of a group of men and women who returned to Africa in 1842 after escaping from Spanish slave traders on the high seas.

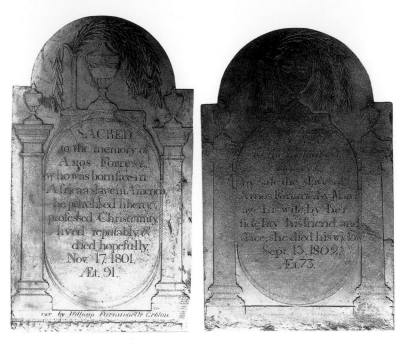

Gravestones of Amos and Violate Fortune, Former Slaves, early 19th century
Located in Jaffrey, New Hampshire. He gained his freedom, bought her,
set her free, and married her. This would not have been
permitted in the Old South.

BURY ME IN A FREE LAND

Excerpt from poem

FRANCES E. W. HARPER

Make me a grave where'er you will,
In a lowly plain, or a lofty hill;
Make it among earth's humblest graves,
But not in a land where men are slaves.

RANDALL WARE

from the novel JUBILEE, 1966

MARGARET WALKER

Randall Ware was a free man because he was born free. He was black
as the Ace of Spades because nothing but the blood of black men coursed
through his veins. He knew the trade of blacksmith when he came to
Georgia and to Lee County with a sack of gold, enough to register himself
as a free man, enough to guarantee the payment of his yearly taxes as
a free man, and enough to buy himself a stake of land through the
confidence and assistance of his white guardian, Randall Wheelwright.
Of course, he would have stayed in Virginia where there were other relatives
who were free and artisans, but Randall Wheelwright had persuaded
him to come to Georgia. And Ware felt a closeness to this white man
whom he respected so highly he had even taken his given name instead
of the foreign name with which he had been christened in the Islands.
Between these two men there was mutual and implicit trust.

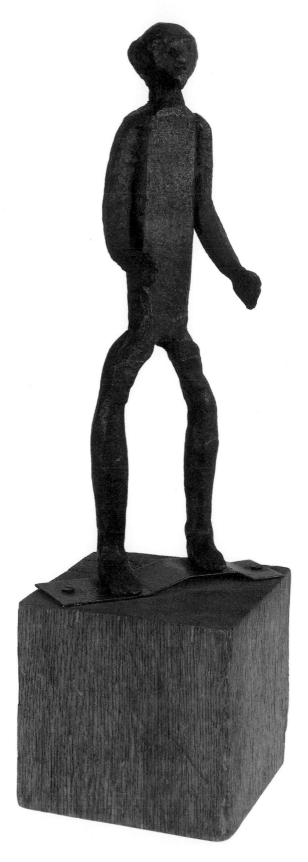

THE SLAVE AND THE IRON LACE

MARGARET DANNER

The craving of Samuel Rouse for clearance to create
was surely as hot as the iron that buffeted him. His passion
for freedom so strong that it molded the smouldering fashions
he laced, for how also could a slave plot
or counterplot such incomparable shapes,

form or reform, for house after house,
the intricate Patio pattern, the delicate
Rose and Lyre, the Debutante Settee,
the complex but famous Grape; frame the classic vein
in an iron bench?

How could he turn an iron Venetian urn, wind the Grape
 Vine, chain
the trunk of a pine with a Round-the-Tree-settee,
mold a Floating Flower tray, a French chair—create all this
in such exquisite fairyland taste, that he'd be freed
and his skill would still resound a hundred years after?

And I wonder if I, with this thick asbestos glove of an
attitude could lace, forge and bend this ton of lead-chained
 spleen surrounding me?
Could I manifest and sustain it into a new free-form screen
of, not necessarily love, but (at the very least, for all
 concerned) grace.

Iron Man, about 1800
Fourteen-inch wrought-iron figure,
discovered under a blacksmith's shack
on a Virginia plantation. Who did it? Who hid it?

The Old Plantation, artist unknown, about 1800

Picture found in Columbia, South Carolina. Probably painted by an African American.

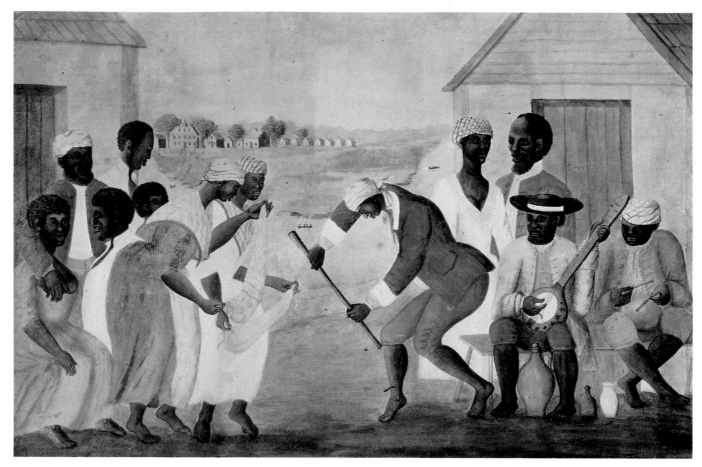

BLACK-EYED SUSIE

FOLK SONG

All I want in this creation's
A pretty little wife and a big plantation.

 Hey, pretty little black-eyed Susie,
 Hey, pretty little black-eyed Susie.

I love my wife, I love my baby,
I love my biscuits sopped in gravy.

All I want to make me happy,
Two little boys to call me pappy.

All I want in this creation's
A pretty little wife and a big plantation.

 Hey, pretty little black-eyed Susie,
 Hey, pretty little black-eyed Susie.

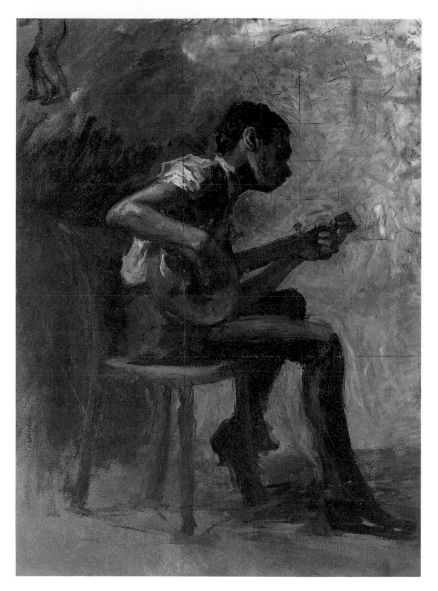

Study for *Negro Boy Dancing,* Thomas Eakins, about 1878

SONG FOR A BANJO DANCE

LANGSTON HUGHES

Shake your brown feet, honey,
Shake your brown feet, chile,
Shake your brown feet, honey,
Shake 'em swift and wil'—
　　Get way back, honey,
　　Do that low-down step.
　　Walk on over, darling,
　　　Now! Come out
　　　With your left.
Shake your brown feet, honey,
Shake 'em, honey chile.

Sun's going down this evening—
Might never rise no mo'.
The sun's going down this very night—
Might never rise no mo'—
So dance with swift feet, honey,
　　(The banjo's sobbing low)
Dance with swift feet, honey—
　　Might never dance no mo'.

Shake your brown feet, Liza,
Shake 'em, Liza, chile,
Shake your brown feet, Liza,
　　(The music's soft and wil')
Shake your brown feet, Liza,
　　(The banjo's sobbing low)
The sun's going down this very night—
　　Might never rise no mo'.

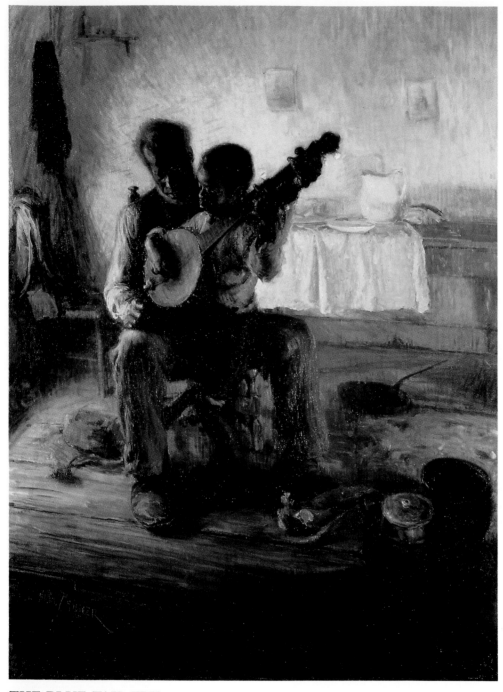

The Banjo Lesson,
Henry Ossawa Tanner, 1893
Although many things changed after the Civil War, some traditions were passed along.

THE BLUE-TAIL FLY

Excerpt from folk song

When I was young, I used to wait
On master and give him the plate,
And pass the bottle when he got dry,
And brush away the blue-tail fly.

Chorus:

Jimmy, crack corn, and I don't care,
Jimmy, crack corn, and I don't care,
Jimmy, crack corn, and I don't care,
Old massa's gone away.

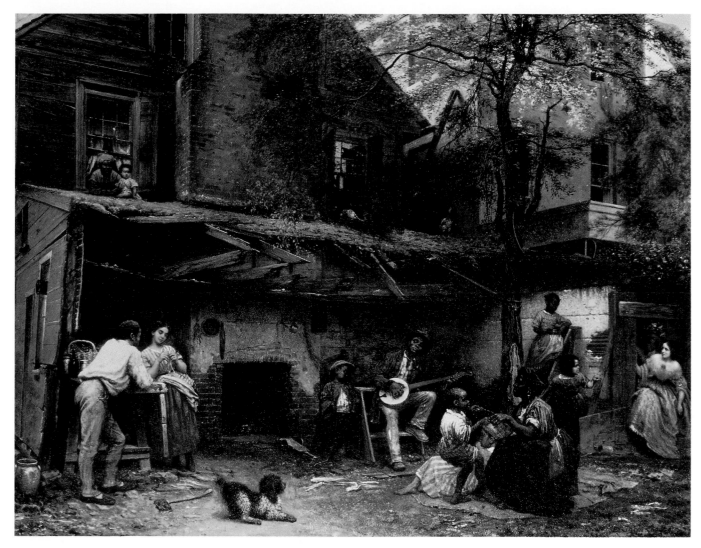

Negro Life in the Old South (Old Kentucky Home), Eastman Johnson, 1859
This painting was inspired by Foster's song. Man with banjo became a familiar character in scenes of Southern life.

MY OLD KENTUCKY HOME

Excerpt from song, 1852

STEPHEN COLLINS FOSTER

The sun shines bright in the old Kentucky home,
'Tis summer, the darkies are gay,
The corn-top's ripe and the meadow's in the bloom,
While the birds make music all the day.
The young folks roll on the little cabin floor,
All merry, all happy and bright:
By'n by Hard Times comes a-knocking at the door,
Then my old Kentucky Home, Good night!

Chorus:

Weep no more, my lady,
Oh! weep no more today!
We will sing one song for the old Kentucky Home,
For the old Kentucky Home far away.

MINSTREL MAN

LANGSTON HUGHES

Because my mouth
Is wide with laughter
And my throat
Is deep with song,
You do not think
I suffer after
I have held my pain
So long.

Because my mouth
Is wide with laughter,
You do not hear
My inner cry,
Because my feet
Are gay with dancing,
You do not know
I die.

Happy John, photograph by McCrary & Bronson, Knoxville, Tennessee, 1897
The minstrel man was sometimes a comic figure, sometimes a tragic one.

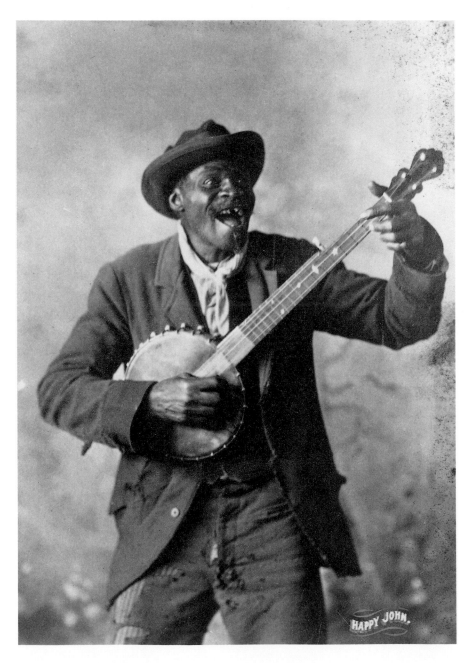

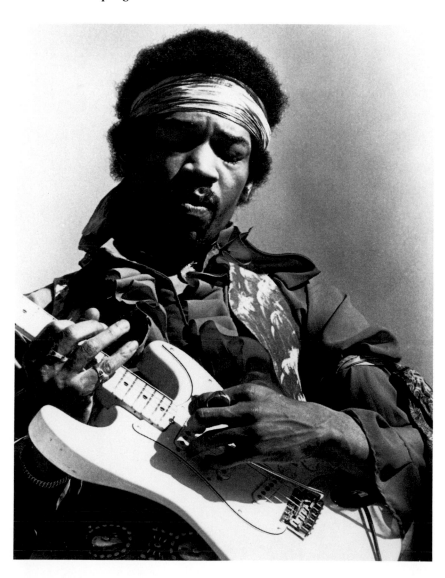

Jimi Hendrix, photograph by Joel Axelrad, about 1965
Today the tragedy and comedy of the minstrel man
are still mixed up together.

THE BALLAD OF JIMI

Song lyrics

CURTIS KNIGHT

Me and my best friend
Travelled down life's highway
We talked of how,
How things should be,
Of peace and love for you and me.

Of a life without hate,
Of a life filled with love.

On that first day he played my guitar
Somehow I knew he'd travel far
Reach out and find his distant star
Many things he would try
For he knew soon he'd die.

Oh why did it happen,
Oh the sadness we must face
Why did it happen
If I could but erase
All the tears that were shed,
All the heartache and the pain.

That is my story
It has no end.
Tho' Jimi's gone
He's not alone
His memory still lingers on
Five years, this he said.
He's not gone
He's just dead.

Flora, artist unknown, 1796

The slave named Flora in this bill of sale could be identified by her silhouette.

SHADOW

RICHARD BRUCE

Silhouette
On the face of the moon
Am I.
A dark shadow in the light.
A silhouette am I
On the face of the moon
Lacking color
Or vivid brightness
But defined all the clearer
Because
I am dark,
Black on the face of the moon.
A shadow am I
Growing in the light,
Not understood as is the day,
But more easily seen
Because
I am a shadow in the light.

ONE SPARK OF PLAYFULNESS

from the novel OUR NIG; OR, SKETCHES FROM THE LIFE OF A FREE BLACK,
IN A TWO-STORY WHITE HOUSE, NORTH, SHOWING THAT SLAVERY'S
SHADOWS FALL EVEN THERE, 1859

HARRIET E. ADAMS WILSON

Strange, one spark of playfulness could remain amid such constant toil;
but her natural temperament was in a high degree mirthful, and the
encouragement she received from Jack and the hired men, constantly
nurtured the inclination.

Eel Spearing at Setauket, William Sidney Mount, 1845
Life on Long Island, New York, before the Civil War. The woman is free, strong, and
clearly in charge of things.

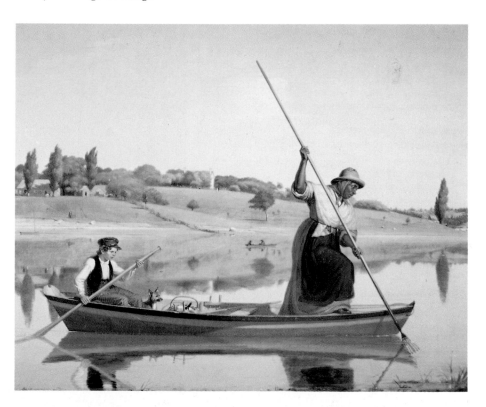

THE SLAVE AUCTION

FRANCES E. W. HARPER

The sale began—young girls were there,
 Defenceless in their wretchedness,
Whose stifled sobs of deep despair
 Revealed their anguish and distress.

And mothers stood with streaming eyes,
 And saw their dearest children sold;
Unheeded rose their bitter cries,
 While tyrants bartered them for gold.

And woman, with her love and truth—
 For these in sable forms may dwell—
Gazed on the husband of her youth,
 With anguish none may paint or tell.

And men, whose sole crime was their hue,
 The impress of their Maker's hand,
And frail and shrieking children, too,
 Were gathered in that mournful band.

Ye who have laid your love to rest,
 And wept above their lifeless clay,
Know not the anguish of that heart,
 Whose loved are rudely torn away.

Ye may not know how desolate
 Are husbands rudely forced to part,
And how a dull and heavy weight
 Will press the life-drops from the heart.

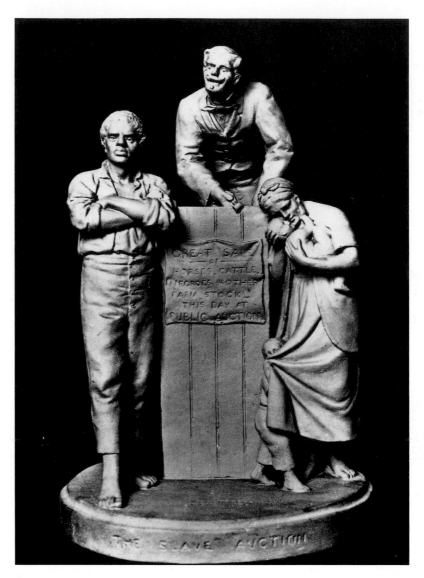

Slave Auction, John Rogers, 1859
Slavery, by then illegal in the Northern states, continued in the South.

RUNAGATE RUNAGATE

ROBERT HAYDEN

Runs falls rises stumbles on from darkness into darkness
and the darkness thicketed with shapes of terror
and the hunters pursuing and the hounds pursuing
and the night cold and the night long and the river
to cross and the jack-muh-lanterns beckoning beckoning
and blackness ahead and when shall I reach that somewhere
morning and keep on going and never turn back and keep on going

> Runagate
>> Runagate
>>> Runagate

Many thousands rise and go
many thousands crossing over

> > > O mythic North
> > > O star-shaped yonder Bible city

Some go weeping and some rejoicing
some in coffins and some in carriages
some in silks and some in shackles

> Rise and go or fare you well

No more auction block for me
no more driver's lash for me

> If you see my Pompey, 30 yrs of age,
> new breeches, plain stockings, negro shoes;
> if you see my Anna, likely young mulatto
> branded E on the right cheek, R on the left,
> catch them if you can and notify subscriber.
> Catch them if you can, but it won't be easy.
> They'll dart underground when you try to catch them,
> plunge into quicksand, whirlpools, mazes,
> turn into scorpions when you try to catch them.

And before I'll be a slave
I'll be buried in my grave

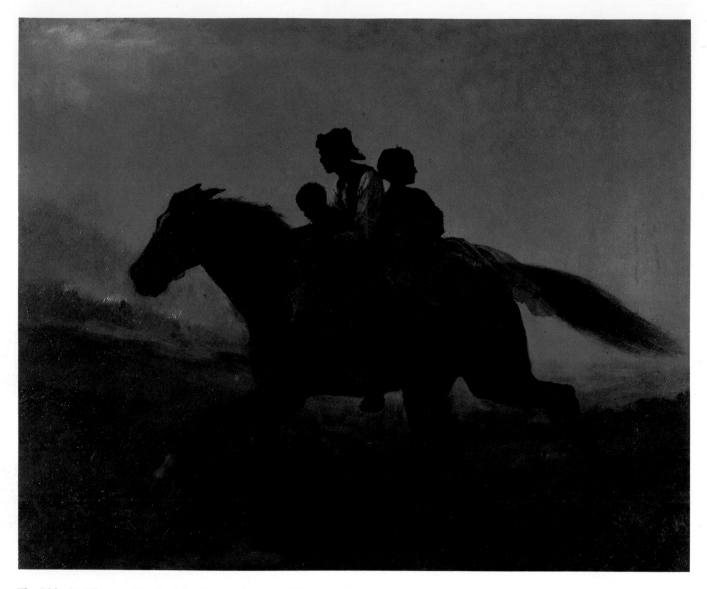

The Ride for Liberty — The Fugitive Slaves, Eastman Johnson, about 1862
Men, women, and children escaped from slavery in any way they could. Some were recaptured and punished or killed.

North star and bonanza gold
I'm bound for the freedom, freedom-bound
and oh Susyanna don't you cry for me

 Runagate
 Runagate

II.
Rises from their anguish and their power,

 Harriet Tubman,

 woman of earth, whipscarred,
 a summoning, a shining

Mean to be free

And this was the way of it, brethren brethren,
way we journeyed from Can't to Can.
Moon so bright and no place to hide,
the cry up and the patterollers riding,
hound dogs belling in bladed air.
And fear starts a-murbling, Never make it,
we'll never make it. *Hush that now,*
and she's turned upon us, levelled pistol
glinting in the moonlight:
Dead folks can't jaybird-talk, she says;
you keep on going now or die, she says.

Wanted Harriet Tubman alias The General
alias Moses Stealer of Slaves

In league with Garrison Alcott Emerson
Garrett Douglass Thoreau John Brown

Armed and known to be Dangerous

Wanted Reward Dead or Alive

Tell me, Ezekiel, oh tell me do you see
mailed Jehovah coming to deliver me?

Hoot-owl calling in the ghosted air,
five times calling to the hants in the air.
Shadow of a face in the scary leaves,
shadow of a voice in the talking leaves

Come ride-a my train

Oh that train, ghost-story train
through swamp and savanna movering movering,
over trestles of dew, through caves of the wish,
Midnight Special on a sabre track movering movering,
first stop Mercy and the last Hallelujah.

Come ride-a my train

Mean mean mean to be free.

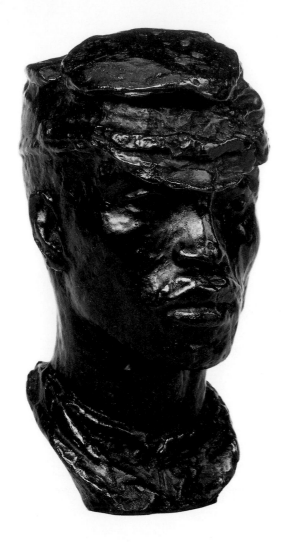

Head of a Young Man (study for a soldier in *The Shaw Memorial*), Augustus Saint-Gaudens, about 1884–87

One of many Northern soldiers who demonstrated their skill and courage in the Civil War.

NEGRO SOLDIER'S CIVIL WAR CHANT

Marching song

Ole Abe (God bless 'is ole soul!)
Got a plenty good victuals, an' a plenty good clo'es.
Got powder, an' shot, an' lead,
To bust in Adam's liddle Confed'
In dese hard times.

Oh, once dere wus union, an' den dere wus peace;
De slave, in de cornfield, bare up to his knees.
But de Rebel's in gray, an' Sesesh's in de way,
An' de slave'll be free
In dese hard times.

THE ASSAULT ON FORT WAGNER

from an eyewitness account of the attack by the 54th Massachusetts Regiment, commanded by Colonel Robert Gould Shaw, at Fort Wagner, South Carolina, July 18, 1863

NATHANIEL PAIGE, REPORTER FOR THE NEW YORK *TRIBUNE*

The First Brigade assaulted at dusk, the Fifty-fourth Massachusetts in the front. Col. [Robert Gould] Shaw was shot just as he mounted the parapet of the Fort. Notwithstanding the loss of their colonel, the regiment pushed forward, and more than one-half succeeded in reaching the inside of the fort. Three standard-bearers were shot, but the flag was held by the regiment until their retreat. The regiment went into action commanded by their colonel and a full staff of officers; it came out led by Second Lieutenant Higginson—a nephew of Col. H[igginson]—he being the highest officer left to command, all ranking being either killed or wounded. General Strong's brigade was led out by Maj. [Josiah] Plimpton of the Third New Hampshire. General Strong received a mortal wound almost at the commencement of the action; Colonel Shaw was killed, and all the other colonels severely wounded. The First Brigade having been repulsed with such severe loss, the Second Brigade was ordered to move. Colonel Putnam led his brigade into the fort, which he held for half an hour without being reinforced. The enemy succeeded in bringing to bear against him ten or twelve brass howitzers, loaded with grape and canister, when the slaughter became so terrible that he was forced to retire, having lost nearly all of his officers. About fifty of the Fifty-fourth Massachusetts were taken prisoners; none have been exchanged; I believe all reports as to harsh treatment of our colored prisoners are untrue; I have reason to think they are treated as prisoners of war. General Gillmore and staff ridiculed Negro troops; the evident purpose of putting the Negroes in advance was to dispose of the ideas that the Negroes could fight; Major Smith [Lt. Col. E. W. Smith] advised General Gillmore to put the Negroes at the head of the assaulting party and get rid of them. On the previous week [Maj.] Gen. [Alfred H.] Terry had made unfavorable mention of the Fifty-fourth Massachusetts for gallantry on James Island. Many of General Terry's officers spoke of them unfavorably before and favorably since the action referred to [the assault on Fort Wagner].

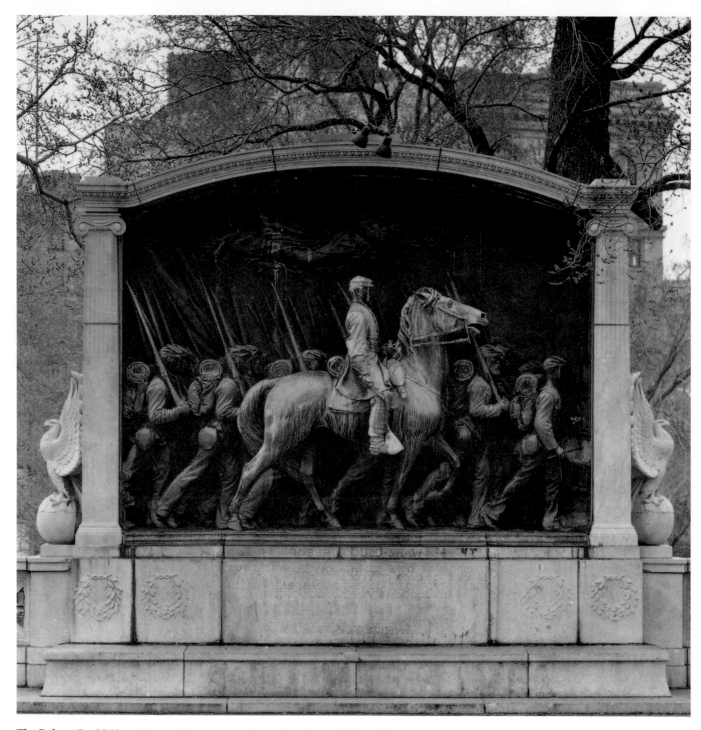

The Robert Gould Shaw Memorial, Augustus Saint-Gaudens, 1884—97
Located on the Boston Common, it commemorates the heroes of the 54th Massachusetts Regiment.

TWO MONTHS AFTER MARCHING THROUGH BOSTON

from FOR THE UNION DEAD

ROBERT LOWELL

Two months after marching through Boston,
half the regiment was dead;
at the dedication,
William James could almost hear the bronze Negroes breathe.

Their moment sticks like a fishbone
in the city's throat.
Its Colonel is as lean
as a compass-needle.

He has an angry wrenlike vigilance,
a greyhound's gentle tautness;
he seems to wince at pleasure
and suffocate for privacy.

He is out of bounds now. He rejoices in man's lovely,
peculiar powers to choose life and die —
when he leads his black soldiers to death,
he cannot bend his back.

On a thousand small town New England greens,
the old white churches hold their air
of sparse, sincere rebellion; frayed flags
quilt the graveyards of the Grand Army of the Republic.

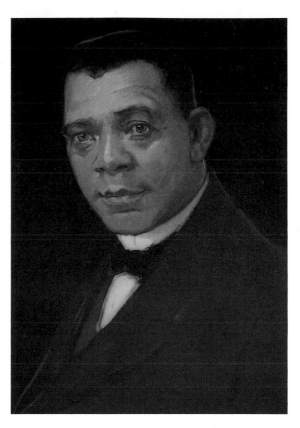

Booker T. Washington,
William E. Scott, 1916

WHAT THIS MEMORIAL STANDS FOR

from a speech by Booker T. Washington at the dedication of the Shaw Memorial
in Boston, Massachusetts, Memorial Day, 1897

The black man who cannot let love and sympathy go out to the white man
is but half free. The white man who would close the shop or factory against
a black man seeking an honest living is but half free. The full measure
of the fruit of Fort Wagner and all that this monument stands for will
not be realized until every man covered by a black skin shall, by patience
and natural effort, grow to the height where no man in our land will be
tempted to degrade himself by withholding from his black brother any
opportunity he himself would possess.

A DIFFERENT IMAGE

DUDLEY RANDALL

The age
requires this task:
create
a different image;
re-animate
the mask.

Shatter the icons of slavery and fear.
Replace
the leer
of the minstrel's burnt-cork face
with a proud, serene
and classic bronze of Benin.

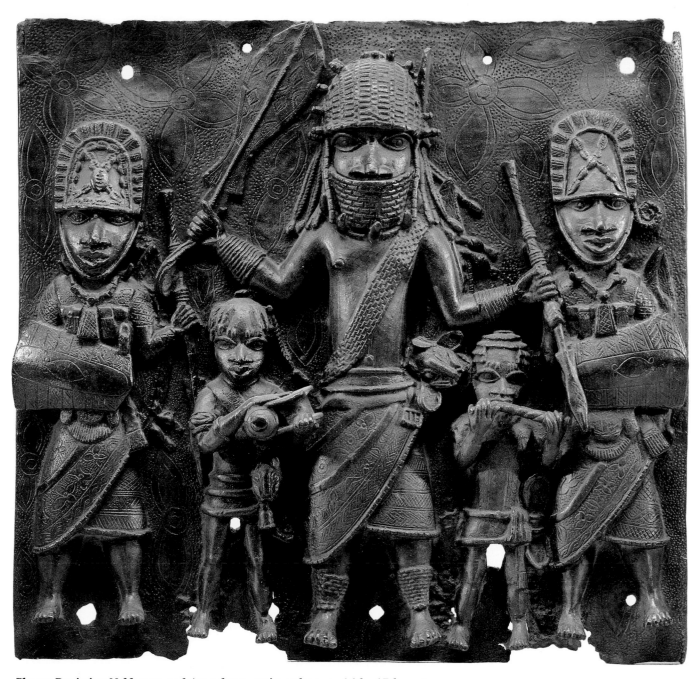

Plaque Depicting Nobleman and Attendants, artist unknown, 16th–17th century
The warrior tradition of some African Americans is reflected in this bronze sculpture from the Court of Benin, Nigeria.

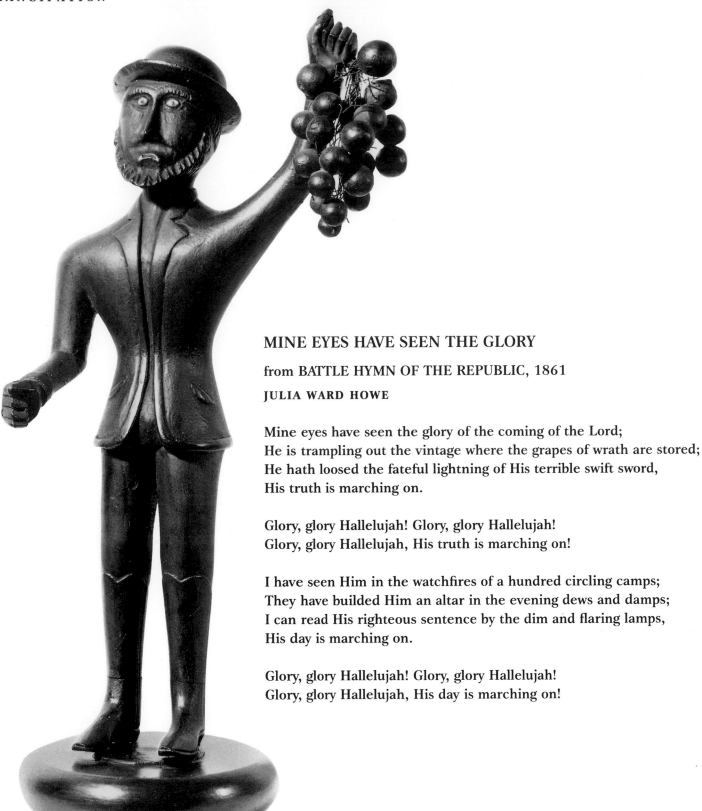

MINE EYES HAVE SEEN THE GLORY

from BATTLE HYMN OF THE REPUBLIC, 1861

JULIA WARD HOWE

Mine eyes have seen the glory of the coming of the Lord;
He is trampling out the vintage where the grapes of wrath are stored;
He hath loosed the fateful lightning of His terrible swift sword,
His truth is marching on.

Glory, glory Hallelujah! Glory, glory Hallelujah!
Glory, glory Hallelujah, His truth is marching on!

I have seen Him in the watchfires of a hundred circling camps;
They have builded Him an altar in the evening dews and damps;
I can read His righteous sentence by the dim and flaring lamps,
His day is marching on.

Glory, glory Hallelujah! Glory, glory Hallelujah!
Glory, glory Hallelujah, His day is marching on!

Man with Grapes, artist unknown, about 1875
Folk art found in Maine.

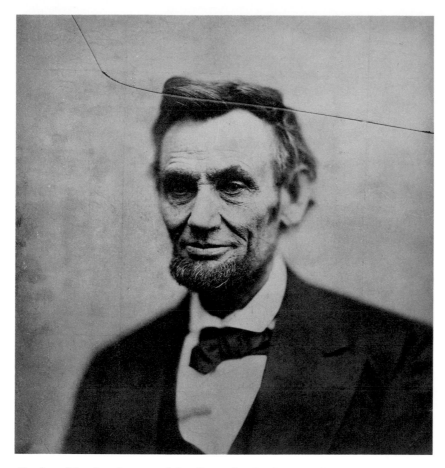

Abraham Lincoln, photograph by Alexander Gardner, April 10, 1865

Lincoln said: "As I would not be a *slave,* so I would not be a *master.* This expresses my idea of democracy—Whatever differs from this, to the extent that it differs, is no democracy."

THE EMANCIPATION PROCLAMATION

from the War Department, Adjutant General's Office, General Orders No. 139, September 24, 1862

I, Abraham Lincoln, president of the United States of America, and commander in chief of the army and navy thereof, do hereby proclaim and declare . . . :

That on the first day of January, in the year of our Lord one thousand eight hundred and sixty-three, all persons held as slaves within any state or designated part of a state, the people whereof shall then be in rebellion against the United States, shall be then, thenceforward, and forever free; and the executive government of the United States, including the military and naval authority thereof, will recognize and maintain the freedom of such persons, and will do no act or acts to repress such persons, or any of them, in any efforts they may make for their actual freedom.

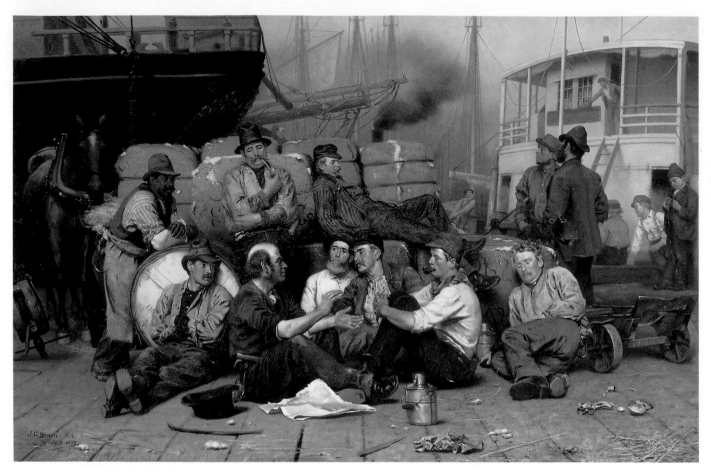

The Longshoreman's Noon, John George Brown, 1879
Men in the North take a break from unloading cargo. Cotton was not "king" to them.

ROLL THE COTTON DOWN

FOLK SONG

Oh, away down South where I was born,
Oh, roll the cotton down,
Away down South where I was born,
Oh, roll the cotton down.

A dollar a day is the white man's pay,
Oh, roll the cotton down,
Oh, a dollar a day is the white man's pay,
Oh, roll the cotton down.

I thought I heard our old man say,
Oh, roll the cotton down,
I thought I heard our old man say,
Oh, roll the cotton down.

We're homeward bound to Mobile Bay,
Oh, roll the cotton down,
We're homeward bound to Mobile Bay,
Oh, roll the cotton down.

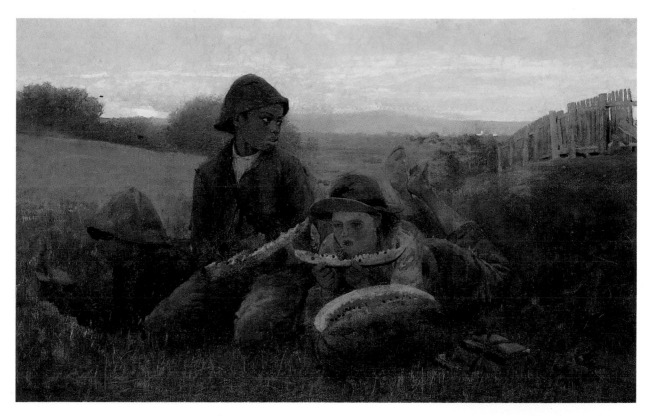

The Watermelon Boys, Winslow Homer, 1876
Southern life imagined by a Northern artist.

MORNINGS, BEFORE DAYLIGHT

from the novel THE ADVENTURES OF HUCKLEBERRY FINN, 1884

MARK TWAIN (SAMUEL CLEMENS)

Mornings, before daylight, I slipped into corn fields and borrowed a watermelon, or a mushmelon, or a punkin, or some new corn, or things of that kind. Pap always said it warn't no harm to borrow things, if you was meaning to pay them back, sometime; but the widow said it warn't anything but a soft name for stealing, and no decent body would do it. Jim said he reckoned the widow was partly right and pap was partly right; so the best way would be for us to pick out two or three things from the list and say we wouldn't borrow them any more — then he reckoned it wouldn't be no harm to borrow the others. So we talked it over all one night, drifting along down the river, trying to make up our minds whether to drop the watermelons, or the cantelopes, or the mushmelons, or what. But towards daylight we got it all settled satisfactory, and concluded to drop crabapples and p'simmons. We warn't feeling just right, before that, but it was all comfortable now. I was glad the way it come out, too, because crabapples ain't ever good, and the p'simmons wouldn't be ripe for two or three months yet.

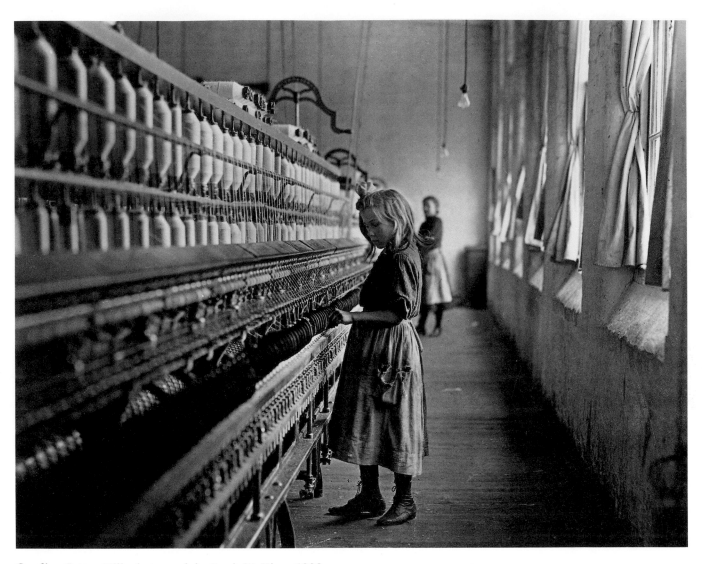

Carolina Cotton Mill, photograph by Lewis W. Hine, 1908
Slavery had ended, but people of both races were still slaves to "King Cotton."

THE HUM OF THE COTTON-MILLS

from the book THE SOULS OF BLACK FOLK, 1903

W. E. B. DU BOIS

The hum of the cotton-mills is the newest and most significant thing in the New South to-day. All through the Carolinas and Georgia, away down to Mexico, rise these gaunt red buildings, bare and homely, and yet so busy and noisy withal that they scarce seem to belong to the slow and sleepy land. Perhaps they sprang from dragons' teeth. So the Cotton Kingdom still lives; the world still bows beneath her sceptre. Even the markets that once defied the *parvenu* have crept one by one across the seas, and then slowly and reluctantly, but surely, have started toward the Black Belt. . . .

Under such a system all labor is bound to suffer. Even the white laborers are not yet intelligent, thrifty, and well trained enough to maintain themselves against the powerful inroads of organized capital. The results among them, even, are long hours of toil, low wages, child labor, and lack of protection against usury and cheating. But among the black laborers all this is aggravated, first, by a race prejudice which varies from a doubt and distrust among the best element of whites to a frenzied hatred among the worst; and, secondly, it is aggravated, as I have said before, by the wretched economic heritage of the freedmen from slavery. With this training it is difficult for the freedman to learn to grasp the opportunities already opened to him, and the new opportunities are seldom given him, but go by favor to the whites.

LOOK OUR TIMES IN THE FACE

from the book DEMOCRATIC VISTAS, 1871

WALT WHITMAN

I say we had best look our times and lands searchingly in the face, like a physician diagnosing some deep disease. Never was there, perhaps, more hollowness of heart than at present, and here in the United States. Genuine belief seems to have left us. The underlying principles of the States are not honestly believ'd in, (for all this hectic glow, and these melodramatic screamings,) nor is humanity itself believ'd in. What penetrating eye does not everywhere see through the mask? The spectacle is appalling. We live in an atmosphere of hypocrisy throughout. . . . The depravity of the business classes of our country is not less than has been supposed, but infinitely greater. The official services of America, national, state, and municipal, in all their branches and departments, except the judiciary, are saturated in corruption, bribery, falsehood, maladministration; and the judiciary is tainted. The great cities reek with respectable as much as non-respectable robbery and scoundrelism. . . . The best class we show, is but a mob of fashionably dress'd speculators and vulgarians. . . . I say that our New World democracy, however great a success in uplifting the masses out of their sloughs, in materialistic development, products, and in a certain highly-deceptive superficial popular intellectuality, is, so far, an almost complete failure in its social aspects, and in really grand religious, moral, literary, and esthetic results. In vain do we march with unprecedented strides to empire so colossal, outvying the antique, beyond Alexander's, beyond the proudest sway of Rome. In vain have we annex'd Texas, California, Alaska, and reach north for Canada and south for Cuba. It is as if we were somehow being endow'd with a vast and more and more thoroughly-appointed body, and then left with little or no soul.

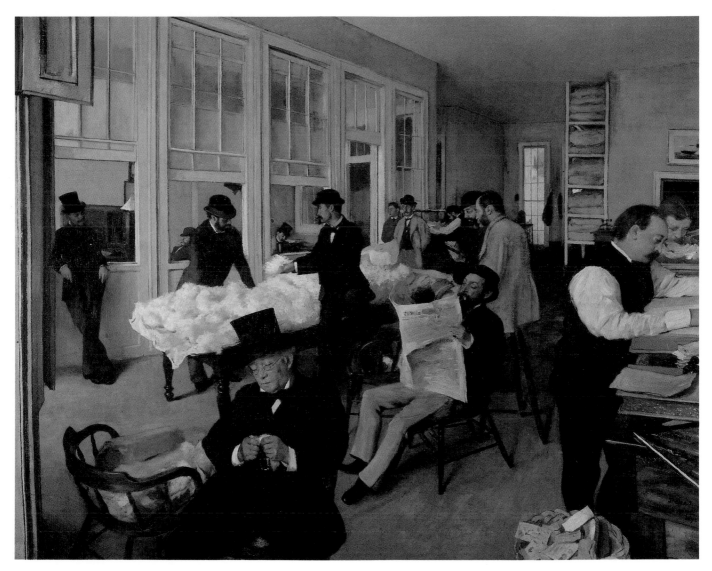

The Cotton Market at New Orleans (or *Portraits in an Office*), Edgar Degas, 1873

Degas, visiting the city, wrote: "Nothing but cotton, one lives for cotton and from cotton." After the Civil War, the South was largely dependent on this one crop.

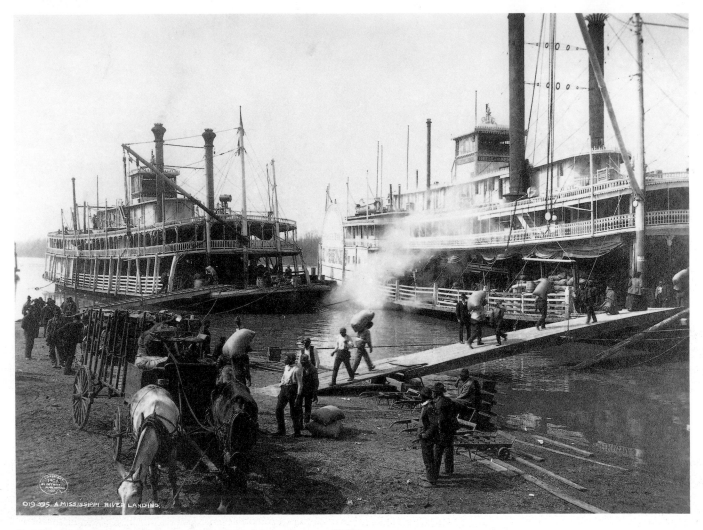

Loading Cotton on the Mississippi, photographer unknown, 1906
Some things didn't change very much.

OL' MAN RIVER

Song lyrics from the musical SHOW BOAT, 1927

OSCAR HAMMERSTEIN II

Ol' Man River, dat Ol' Man River,
he must know sump-in', but don't say noth-in',
he jus' keeps roll-in', he keeps on roll-in' along.
He don't plant 'taters, he don't plant cot-ton,
an' dem dat plants 'em is soon for-gotten;
but Ol' Man Riv-er, he jus' keeps roll-in' along.

You an' me, we sweat an' strain,
bo-dy all ach-in' an' racked wid pain.
"Tote dat barge!" "Lift dat bale,"
git a lit-tle drunk an' you land in jail.
Ah gits wea-ry and sick of try-in',
Ah'm tired of liv-in' an' skeered of dy-in'.
But Ol' Man Riv-er, he jus' keeps roll-in' a-long.

THE NEGRO SPEAKS OF RIVERS

LANGSTON HUGHES

(To W. E. B. Du Bois)

I've known rivers:
I've known rivers ancient as the world and older than the flow
 of human blood in human veins.

My soul has grown deep like the rivers.

I bathed in the Euphrates when dawns were young.
I built my hut near the Congo and it lulled me to sleep.
I looked upon the Nile and raised the pyramids above it.
I heard the singing of the Mississippi when Abe Lincoln
 went down to New Orleans, and I've seen its muddy
 bosom turn all golden in the sunset.

I've known rivers:
Ancient, dusky rivers.

My soul has grown deep like the rivers.

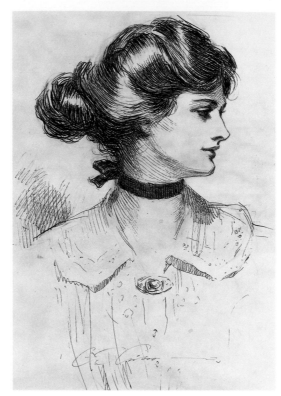

A *Daughter of the South,*
Charles Dana Gibson,
drawing for *Collier's Weekly,*
July 31, 1909

SOUTHERN MANSION

ARNA BONTEMPS

Poplars are standing there still as death
And ghosts of dead men
Meet their ladies walking
Two by two beneath the shade
And standing on the marble steps.

There is a sound of music echoing
Through the open door
And in the field there is
Another sound tinkling in the cotton:
Chains of bondmen dragging on the ground.

The years go back with an iron clank,
A hand is on the gate,
A dry leaf trembles on the wall.
Ghosts are walking.
They have broken roses down
And poplars stand there still as death.

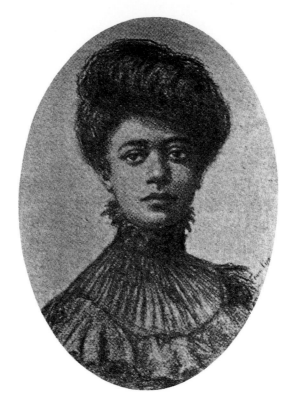

The New Negro Woman,
John Henry Adams, Jr.,
drawing for *Voice of the Negro,*
August 1904

This young woman, a college
student, also looks confident
of her future. Education was
seen as one of the keys.

THE NEW NEGRO

JAMES EDWARD MCCALL

He scans the world with calm and fearless eyes,
 Conscious within of powers long since forgot;
At every step, new man-made barriers rise
 To bar his progress—but he heeds them not.
He stands erect, though tempests round him crash,
 Though thunder bursts and billows surge and roll;
He laughs and forges on, while lightnings flash
 Along the rocky pathway to his goal.
Impassive as a Sphinx, he stares ahead—
 Foresees new empires rise and old ones fall;
While caste-mad nations lust for blood to shed,
 He sees God's finger writing on the wall.
With soul awakened, wise and strong he stands,
Holding his destiny within his hands.

LEARNING TO READ

from SKETCHES OF SOUTHERN LIFE, 1872

FRANCES E. W. HARPER

Very soon the Yankee teachers
 Came down and set up school;
But, oh! how the Rebs did hate it, —
 It was agin' their rule.

Our masters always tried to hide
 Book learning from our eyes;
Knowledge didn't agree with slavery —
 'Twould make us all too wise.

But some of us would try to steal
 A little from the book,
And put the words together,
 And learn by hook or crook. . . .

Well, the Northern folks kept sending
 The Yankee teachers down;
And they stood right up and helped us,
 Though the Rebs did sneer and frown.

And I longed to read my Bible,
 For precious words it said;
But when I begun to learn it,
 Folks just shook their heads.

And said there is no use trying,
 Oh! Chloe, you're too late;
But I was rising sixty,
 I had no time to wait.

So I got a pair of glasses,
 And straight to work I went,
And never stopped till I could read
 The hymns and Testament.

Then I got a little cabin,
 A place to call my own —
And I felt as independent
 As the queen upon her throne.

THE SCHOOLHOUSE WAS A LOG HUT

from the book THE SOULS OF BLACK FOLK, 1903

W. E. B. DU BOIS

The schoolhouse was a log hut, where Colonel Wheeler used to shelter his corn. It sat in a lot behind a rail fence and thorn bushes, near the sweetest of springs. There was an entrance where a door once was, and within, a massive rickety fireplace; great chinks between the logs served as windows. Furniture was scarce. A pale blackboard crouched in the corner. My desk was made of three boards, reinforced at critical points, and my chair, borrowed from the landlady, had to be returned every night. Seats for the children — these puzzled me much. I was haunted by a New England vision of neat little desks and chairs, but, alas! the reality was rough plank benches without backs, and at times without legs....

There they sat, nearly thirty of them, on the rough benches, their faces shading from a pale cream to a deep brown, the little feet bare and swinging, the eyes full of expectation, with here and there a twinkle of mischief, and the hands grasping Webster's blue-black spelling-book. I loved my school, and the fine faith the children had in the wisdom of their teacher was truly marvellous. We read and spelled together, wrote a little, picked flowers, sang, and listened to stories of the world beyond the hill.

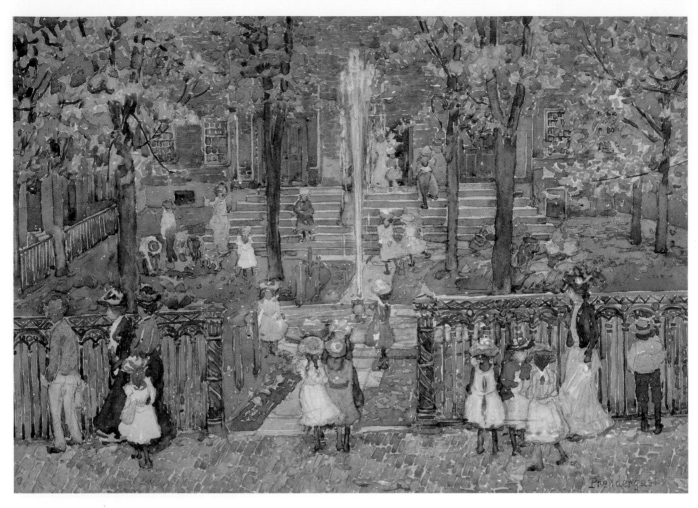

West Church, Boston, Maurice Brazil Prendergast, about 1901
Children walk together into an old building then used as a public library in Massachusetts.

WALK TOGETHER CHILDREN

Excerpt from folk poem

Walk together children,
Don't you get weary,
Walk together children,
Don't you get weary.
Oh, talk together children,
Don't you get weary,
There's a great camp meeting in the Promised Land.

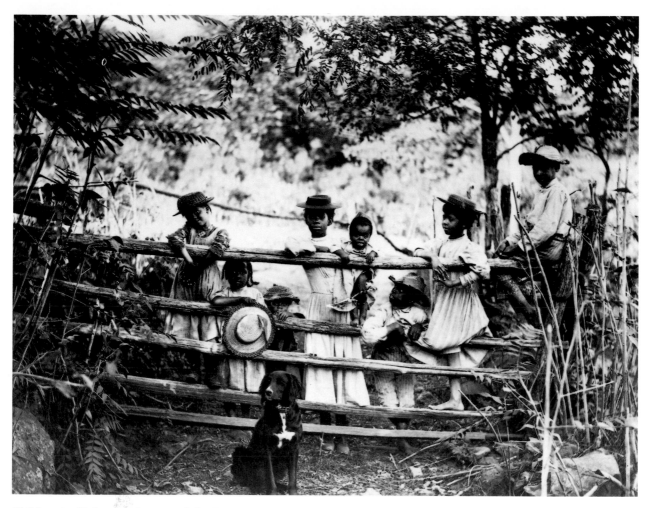

Children in Alabama, photograph by Frances Benjamin Johnston, about 1895

Children of the two races did not walk together in Alabama at the turn of the century.
Schools, for example, were separate and unequal. But it was still possible to learn.

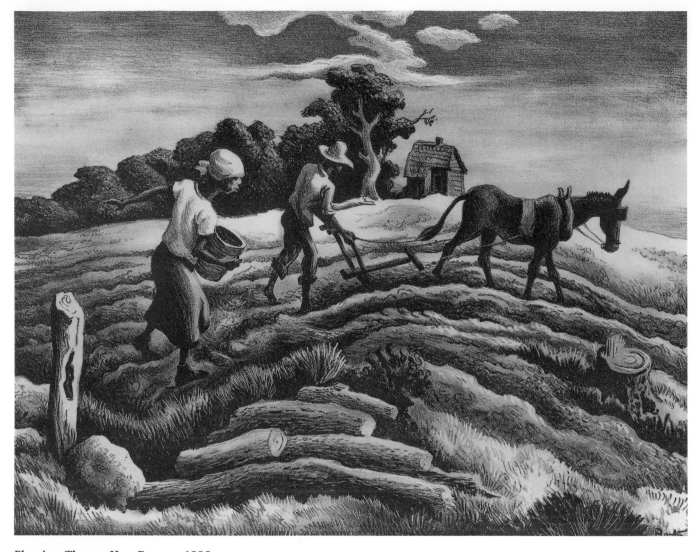

Planting, Thomas Hart Benton, 1939

A couple working their Southern farm during the Depression of the 1930s.

A LONG TIME AGO

FOLK SONG

Way down South where I was born,
Way ay ay yah,
I've picked the cotton and hoed the corn,
Oh a long time ago.

In the good old State of Alabam',
Way ay ay yah,
So I've packed my bag, and I'm going away,
Oh a long time ago.

When I was young and in my prime,
Oh, I served my time in the Black Ball Line.

I'm going away to Mobile Bay,
Where they screw the cotton by the day.

Five dollars a day is a white man's pay,
And a dollar and a half is a black man's pay.

When the ship is loaded, I'm going to sea,
Way ay ay yah,
For a sailor's life is the life for me,
Oh a long time ago.

MOTHER TO SON

LANGSTON HUGHES

Well, son, I'll tell you:
Life for me ain't been no crystal stair.
It's had tacks in it,
And splinters,
And boards torn up,
And places with no carpet on the floor —
Bare.
But all the time
I'se been a-climbin' on,
And reachin' landin's,
And turnin' corners,
And sometimes goin' in the dark
Where there ain't been no light.
So boy, don't you turn back.
Don't you set down on the steps
'Cause you finds it's kinder hard.
Don't you fall now —
For I'se still goin', honey,
I'se still climbin',
And life for me ain't been no crystal stair.

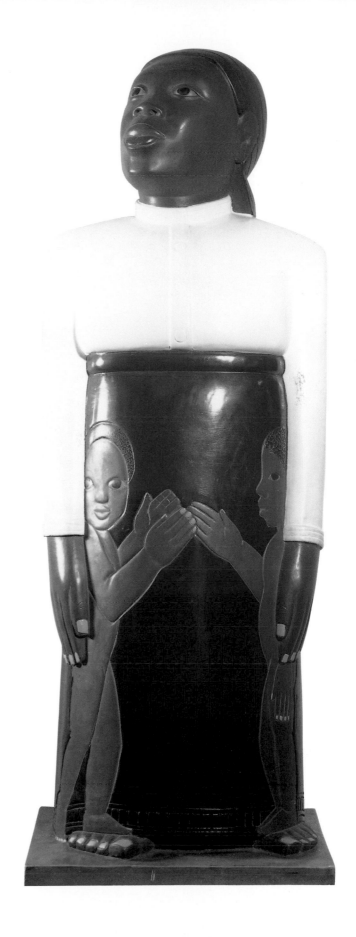

Forever Free, Sargent Claude Johnson, 1933
Freedom lives within us and gives us strength

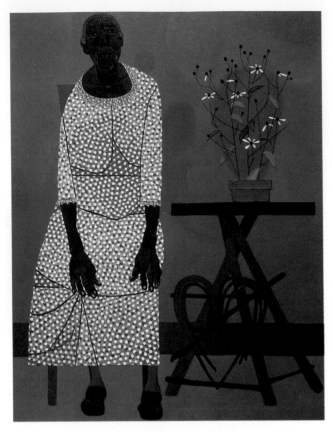

Portrait of a Farmer's Wife, Robert Gwathmey, 1951
Learning to let go of the past.

OLD MARY

GWENDOLYN BROOKS

My last defense
Is the present tense.

It little hurts me now to know
I shall not go

Cathedral-hunting in Spain
Nor cherrying in Michigan or Maine.

DAYBREAK IN ALABAMA

LANGSTON HUGHES

When I get to be a composer
I'm gonna write me some music about
Daybreak in Alabama
And I'm gonna put the purtiest songs in it
Rising out of the ground like a swamp mist
And falling out of heaven like soft dew.
I'm gonna put some tall tall trees in it
And the scent of pine needles
And the smell of red clay after rain
And long red necks
And poppy colored faces
And big brown arms
And the field daisy eyes
Of black and white black white black people
And I'm gonna put white hands
And black hands and brown and yellow hands
And red clay earth hands in it
Touching everybody with kind fingers
And touching each other natural as dew
In that dawn of music when I
Get to be a composer
And write about daybreak
In Alabama.

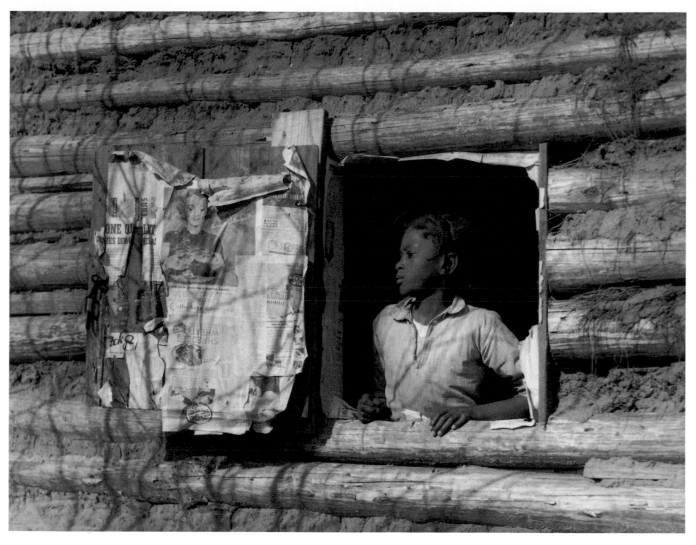

Girl at Gee's Bend, Alabama, photograph by Arthur Rothstein, 1937
Beauty and hope can survive, in spite of hard times.

HIS DOUBLE SELF

from the book THE SOULS OF BLACK FOLK, 1903

W. E. B. DU BOIS

The history of the American Negro is the history of this strife—this longing to attain self-conscious manhood, to merge his double self into a better and truer self. In this merging he wishes neither of the older selves to be lost. He would not Africanize America, for America has too much to teach the world and Africa. He would not bleach his Negro soul in a flood of white Americanism, for he knows that Negro blood has a message for the world. He simply wishes to make it possible for a man to be both a Negro and an American, without being cursed and spit upon by his fellows, without having the doors of opportunity closed roughly in his face.

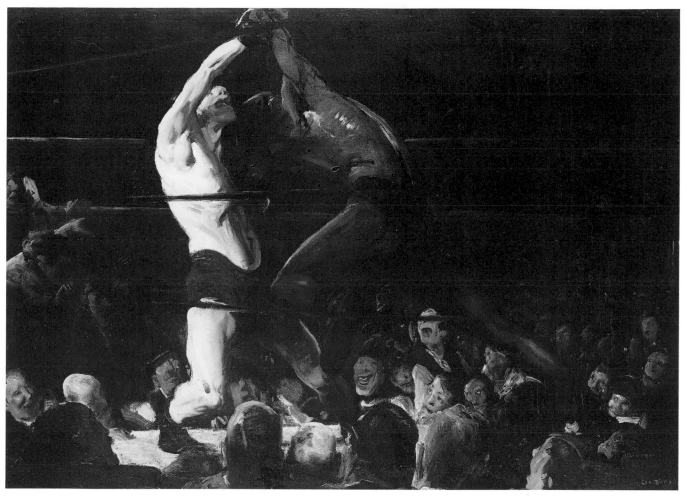

Both Members of This Club, George Wesley Bellows, 1909

Two men accepted as equals because of their effort and their courage.

SOUTHERN ROAD

STERLING A. BROWN

Swing dat hammer—hunh—
Steady, bo;
Swing dat hammer—hunh—
Steady, bo;
Ain't no rush, bebby,
Long ways to go.

Burner tore his—hunh—
Black heart away;
Burner tore his—hunh—
Black heart away;
Got me life, bebby,
An' a day.

Gal's on Fifth Street—hunh—
Son done gone;
Gal's on Fifth Street—hunh—
Son done gone;
Wife's in de ward, bebby,
Babe's not bo'n.

My ole man died—hunh—
Cussin' me;
My ole man died—hunh—
Cussin' me;
Ole lady rocks, bebby,
Huh misery.

Doubleshackled—hunh—
Guard behin';
Doubleshackled—hunh—
Guard behin';
Ball an' chain, bebby,
On my min'.

White man tell me—hunh—
Damn yo' soul;
White man tell me—hunh—
Damn yo' soul;
Got no need, bebby,
To be tole.

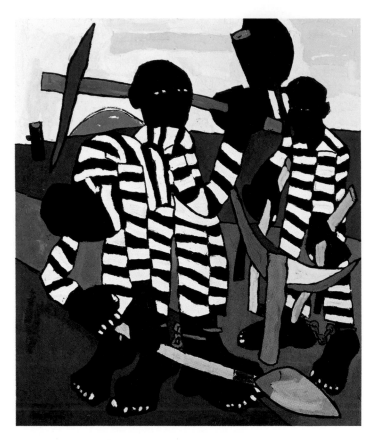

Chain Gang, William H. Johnson, 1939–40
Prisoners sentenced to hard labor in the "bad old days."

Chain gang nevah—hunh—
Let me go;
Chain gang nevah—hunh—
Let me go;
Po' los' boy, bebby,
Evahmo'. . .

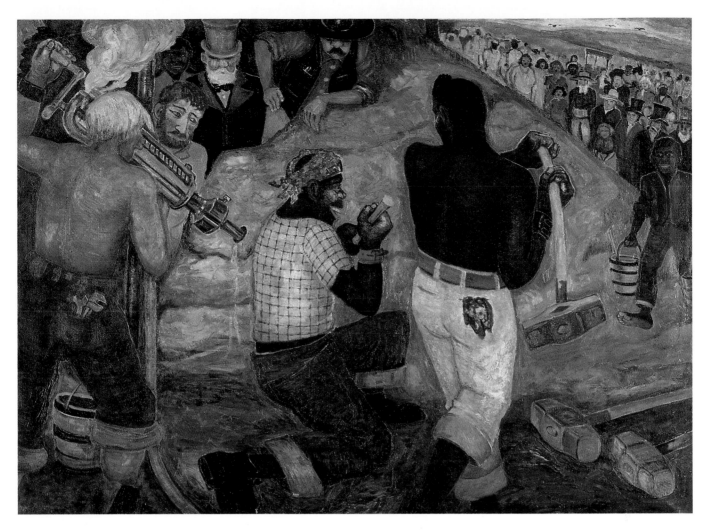

John Henry on the Right, Steam Drill on the Left, Palmer Hayden, 1944—54
Legendary contest of man against man, new tools against old.

THE BEST IN THE LAND

from JOHN HENRY

FOLK SONG

One day his captain told him,
　　How he had bet a man
That John Henry would beat his steam drill down,
　　Cause John Henry was the best in the land,
　　　John Henry was the best in the land.

John Henry kissed his hammer,
　　White man turned on steam,
Shaker held John Henry's trusty steel,
　　Was the biggest race the world had ever seen,
　　　Lord, biggest race the world ever seen.

John Henry on the right side
　　The steam drill on the left,
"Before I'll let your steam drill beat me down,
　　I'll hammer my fool self to death,
　　　Hammer my fool self to death."

LINES TO A NASTURTIUM (A LOVER MUSES)

ANNE SPENCER

Flame-flower, Day-torch, Mauna Loa,
I saw a daring bee, today, pause, and soar,
 Into your flaming heart;
Then did I hear crisp crinkled laughter
As the furies after tore him apart?
 A bird, next, small and humming,
Looked into your startled depths and fled . . .
Surely, some dread sight, and dafter
 Than human eyes as mine can see,
Set the stricken air waves drumming
 In his flight.

Day-torch, Flame-flower, cool-hot Beauty,
I cannot see, I cannot hear your fluty
Voice lure your loving swain,
But I know one other to whom you are in beauty
Born in vain;
Hair like the setting sun,
Her eyes a rising star,
Motions gracious as reeds by Babylon, bar
All your competing;
Hands like, how like, brown lilies sweet,
Cloth of gold were fair enough to touch her feet . . .
Ah, how the senses flood at my repeating,
As once in her fire-lit heart I felt the furies
Beating, beating.

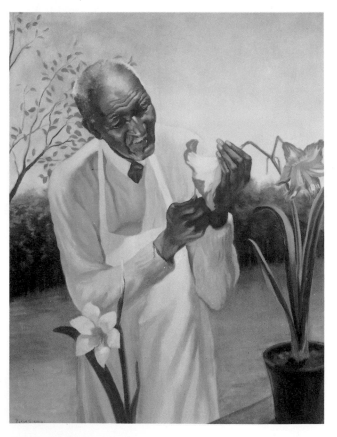

George Washington Carver, Scientist, Betsy Graves Reyneau,
1942

Scientist who received many awards for his efforts to
improve farming in the South.

GEORGE

DUDLEY RANDALL

When I was a boy desiring the title of man
And toiling to earn it
In the inferno of the foundry knockout,
I watched and admired you working by my side,
As, goggled, with mask on your mouth and shoulders bright with sweat,
You mastered the monstrous, lumpish cylinder blocks,
And when they clotted the line and plunged to the floor
With force enough to tear your foot in two,
You calmly stepped aside.

One day when the line broke down and the blocks reared up
Groaning, grinding, and mounted like an ocean wave
And then rushed thundering down like an avalanche,
And we frantically dodged, then braced our heads together
To form an arch to lift and stack them,
You gave me your highest accolade:
You said: "You not afraid of sweat. You strong as a mule."

Now, here, in the hospital,
In a ward where old men wait to die,
You sit, and watch time go by.

You cannot read the books I bring, not even
Those that are only picture books,
As you sit among the senile wrecks,
The psychopaths, the incontinent.

One day when you fell from your chair and stared at the air
With the look of fright which sight of death inspires,
I lifted you like a cylinder block, and said,
'Don't be afraid
Of a little fall, for you'll be here
A long time yet, because you're strong as a mule.''

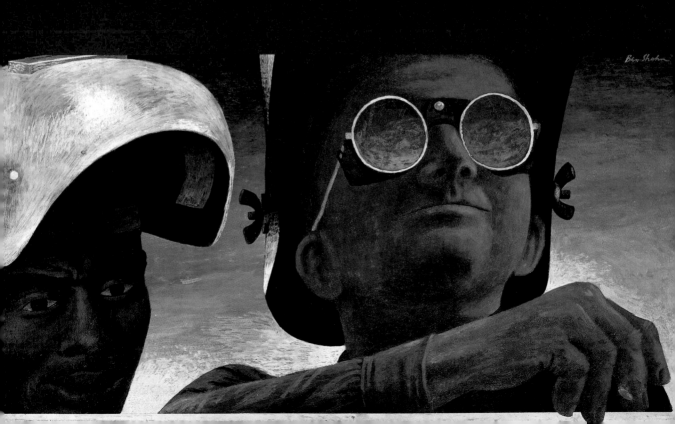

Bill Pickett in "The Bull-Dogger," artist unknown, 1923
Rodeo champion and movie star of the 1920s.

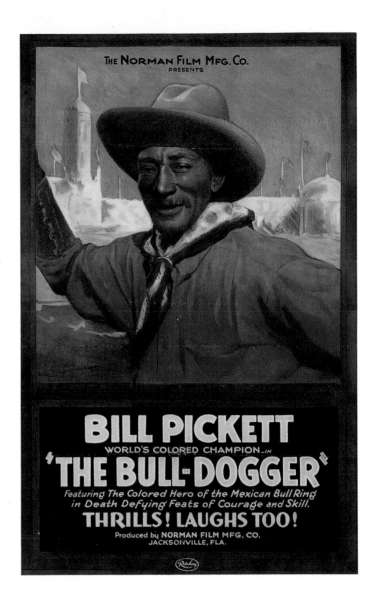

STRONG MEN, RIDING HORSES

GWENDOLYN BROOKS

Lester after the Western

Strong Men, riding horses. In the West
On a range five hundred miles. A Thousand. Reaching
From dawn to sunset. Rested blue to orange.
From hope to crying. Except that Strong Men are
Desert-eyed. Except that Strong Men are
Pasted to stars already. Have their cars
Beneath them. Rentless, too. Too broad of chest
To shrink when the Rough Man hails. Too flailing
To redirect the Challenger, when the challenge
Nicks; slams; buttonholes. Too saddled.

I am not like that. I pay rent, am addled
By illegible landlords, run, if robbers call.

What mannerisms I present, employ,
Are camouflage, and what my mouths remark
To word-wall off that broadness of the dark
Is pitiful.
I am not brave at all.

77

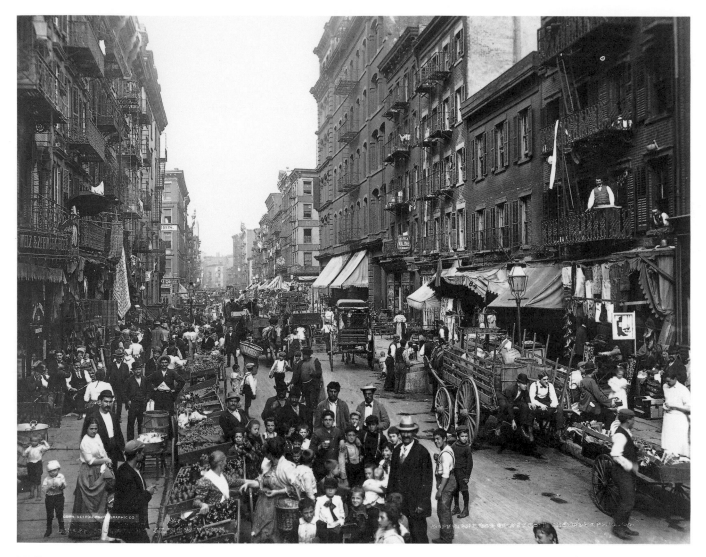

Mulberry Street, New York, photographer unknown, 1906
A typical "melting pot" neighborhood at the turn of the century.

THE MELTING POT

DUDLEY RANDALL

There is a magic melting pot
where any girl or man
can step in Czech or Greek or Scot,
step out American.

Johann and *Jan* and *Jean* and *Juan*,
Giovanni and *Ivan*
step in and then step out again
all freshly christened *John*.

Sam, watching, said, "Why, I was here
even before they came,"
and stepped in too, but was tossed out
before he passed the brim.

And every time Sam tried that pot
they threw him out again.
"Keep out. This is our private pot.
We don't want your black stain."

At last, thrown out a thousand times,
Sam said, "I don't give a damn.
Shove your old pot. You can like it or not,
but I'll be just what I am."

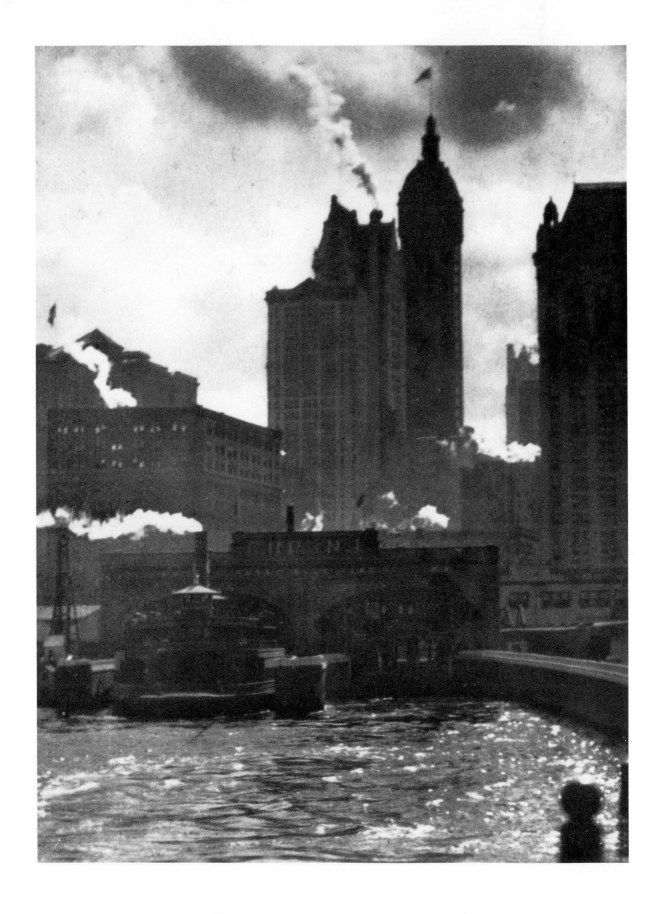

THE WHITE CITY

CLAUDE MCKAY

I will not toy with it nor bend an inch.
Deep in the secret chambers of my heart
I muse my life-long hate, and without flinch
I bear it nobly as I live my part.
My being would be a skeleton, a shell,
If this dark Passion that fills my every mood,
And makes my heaven in the white world's hell,
Did not forever feed me vital blood.
I see the mighty city through a mist —
The strident trains that speed the goaded mass,
The poles and spires and towers vapor-kissed,
The fortressed port through which the great ships pass,
The tides, the wharves, the dens I contemplate,
Are sweet like wanton loves because I hate.

The City of Ambition, photograph by Alfred Stieglitz,
about 1909–10

Manhattan from the Hudson River — hated by some,
loved by others.

MY CITY

JAMES WELDON JOHNSON

When I come down to sleep death's endless night,
The threshold of the unknown dark to cross,
What to me then will be the keenest loss,
When this bright world blurs on my fading sight?
Will it be that no more I shall see the trees
Or smell the flowers or hear the singing birds
Or watch the flashing streams or patient herds?
No, I am sure it will be none of these.

But, ah! Manhattan's sights and sounds, her smells,
Her crowds, her throbbing force, the thrill that comes
From being of her a part, her subtile spells,
Her shining towers, her avenues, her slums —
O God! the stark, unutterable pity,
To be dead, and never again behold my city!

"SUMMERTIME AND THE LIVING . . ."

ROBERT HAYDEN

Nobody planted roses, he recalls,
but sunflowers gangled there sometimes,
tough-stalked and bold
and like the vivid children there unplanned.
There circus-poster horses curveted
in trees of heaven
above the quarrels and shattered glass,
and he was bareback rider of them all.

No roses there in summer —
oh, never roses except when people died —
and no vacations for his elders,
so harshened after each unrelenting day
that they were shouting-angry.
But summer was, they said, the poor folks' time
of year. And he remembers
how they would sit on broken steps amid

The fevered tossings of the dusk, the dark,
wafting hearsay with funeral-parlor fans
or making evening solemn by
their quietness. Feels their Mosaic eyes
upon him, though the florist roses
that only sorrow could afford
long since have bidden them Godspeed.

Oh, summer summer summertime —

Then grim street preachers shook
their tambourines and Bibles in the face
of tolerant wickedness;
then Elks parades and big splendiferous
Jack Johnson in his diamond limousine
set the ghetto burgeoning
with fantasies
of Ethiopia spreading her gorgeous wings.

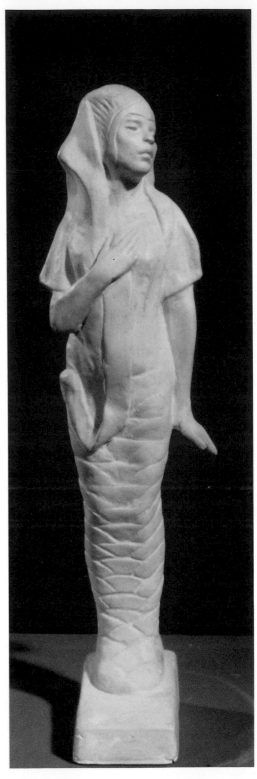

Ethiopia Awakening, Meta Warwick Fuller, 1914
Sculpture symbolizing the "rediscovery" of the
African heritage and a different vision of the future.

THIS MUS' BE HARLEM

from the short story MISS CYNTHIE, about 1920

RUDOLPH FISHER

Then he saw what had caught her attention. They were traveling up Seventh Avenue now, and something was miraculously different. Not the road; that was as broad as ever, wide, white, gleaming in the sun. Not the houses; they were lofty still, lordly, disdainful, supercilious. Not the cars; they continued to race impatiently onward, innumerable, precipitate, tumultuous. Something else, something at once obvious and subtle, insistent, pervasive, compelling.

"David—this mus' be Harlem!"

"Good Lord, Miss Cynthie—!"

"Don' use the name of the Lord in vain, David."

"But I mean—gee!—you're no fun at all. You get everything before a guy can tell you."

"You got plenty to tell me, David. But don' nobody need to tell me this. Look a yonder."

Not just a change of complexion. A completely dissimilar atmosphere. Sidewalks teeming with leisurely strollers, at once strangely dark and bright. Boys in white trousers, berets, and green shirts, with slickened black heads and proud swagger. Bareheaded girls in crisp organdy dresses, purple, canary, gay scarlet. And laughter, abandoned strong Negro laughter, some falling full on the ear, some not heard at all, yet sensed— the warm life-breath of the tireless carnival to which Harlem's heart quickens in summer.

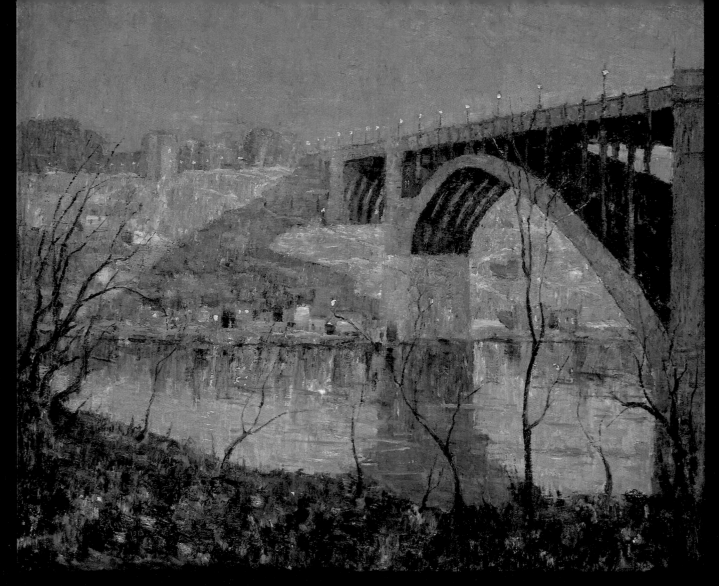

Spring Night, Harlem River, Ernest Lawson, 1913
Magic of the city.

HARLEM — THEN AND NOW

Essay written at age thirteen and published in his school paper,
The Douglass Pilot, 1937

JAMES BALDWIN

I wonder how many of us have ever stopped to think what Harlem was two or three centuries ago? Or how it came to be as it is today? Not many of us. Most of us know in a vague way that the Dutch lived in Harlem 'a long time ago,' and let it go at that. We don't think about how the Indians were driven out, how the Dutch and English fought, or how finally Harlem grew into what it is today. Now I am going to tell you a little about this.

Listen:

17TH CENTURY

In 1636, inspired by glowing accounts of Harlem, a Dr Johannes de la Montagne, his family and a handful of settlers landed at 125th Street and the Harlem River. They landed when Harlem was a wilderness. Nature reigned supreme.

Courageously these people set about making a home out of this wilderness. They chopped down trees, they built their homes, and tried to make something out of the land. It was tough going at first. The houses were hard to heat, the crops refused to grow. They were often cold, hungry, and frightened, a feeling not lessened by the sight of Indians running around in the forest. But they stayed because they couldn't and wouldn't go back.

And one day, in the beginning of Spring, a Dutch housewife discovered a little green shoot growing. 'Look!' she cried. 'Corn is growing!' And it grew. All over, it grew. Farms that before had been thought barren yielded up corn by the bushel. People enlarged their farms, planted more seed. A Danish capitalist, Jochem Pieter, had a farm that extended from 125th to 150th Streets, along the Harlem River. All over people were jubilant. They had nothing to fear. This was 'good earth.'

But the Indians did not like it. The squeak of cart wheels and swish of scythes warned them that their 'happy hunting grounds' would soon be taken away from them.

18TH CENTURY

The 18th Century found Harlem in English hands. She had been conquered in 1664.

Harlem had improved a great deal. The farms were more pretentious. Many people had slaves. All in all, Harlem was a very proper little village. At that time, of course, Seventh Avenue was a mere dirt road, St Nicholas Park was old 'Breakneck Hill' (a very appropriate title), Mt Morris Park was 'Old Snake Hill' and the place where the family went for picnics. There was no Madison Avenue, no Lenox Avenue, and no tenements. There were no sidewalks, no asphalt streets, no large churches and schools, etc. In fact, the schools were just little one-room buildings.

That was Harlem in the 18th century.

19TH CENTURY

Harlem had changed greatly. Now there were streets, or at least public roads. Seventh Avenue was still dirt, though, and people drove up and down in carriages, and in the winter time in sleighs. Men and women on horseback were a common sight. One hundred and twenty-ninth and one hundred and thirtieth streets were residential sections of stately beauty. There were many very fine mansions throughout the section. Where 131st Street playground is now, there once stood an elegant mansion, only recently torn down. Ere a decade had passed, tenements had sprung up. Smooth, dependable asphalt streets replaced rough, muddy roads, and farms and all that goes with them gradually disappeared.

20TH CENTURY

Today, as we all know, Harlem is a large, thickly populated urban community — a city within a city, with fine streets and avenues, parks, playgrounds, churches, schools, apartment houses, theatres, etc.

However, there is still great room for improvement. The tenements people were once so proud of are now rather dangerous firetraps and should be rebuilt. There has been some effort on the part of the Housing Authorities to improve them, but as yet they have only operated in a very small field.

Now we, who are interested in Harlem, hope that the future will bring a steady growth and improvement.

I WANT SO MANY THINGS

from the play A RAISIN IN THE SUN, 1958

LORRAINE HANSBERRY

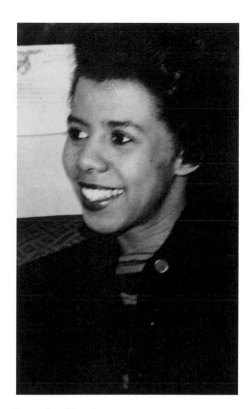

Lorraine Hansberry,
photographer unknown,
about 1960

WALTER I want so many things that they are driving me kind of crazy . . . Mama—look at me.

MAMA I'm looking at you. You a good-looking boy. You got a job, a nice wife, a fine boy and—

WALTER A job. (*Looks at her*) Mama, a job? I open and close car doors all day long. I drive a man around in his limousine and I say, "Yes, sir; no, sir; very good, sir; shall I take the Drive, sir?" Mama, that ain't no kind of job . . . that ain't nothing at all. (*Very quietly*) Mama, I don't know if I can make you understand.

MAMA Understand what, baby?

WALTER (*Quietly*) Sometimes it's like I can see the future stretched out in front of me—just plain as day. The future, Mama. Hanging over there at the edge of my days. Just waiting for me—a big, looming blank space—full of *nothing.* Just waiting for *me.* (*Pause*) Mama—sometimes when I'm downtown and I pass them cool, quiet-looking restaurants where them white boys are sitting back and talking 'bout things . . . sitting there turning deals worth millions of dollars . . . sometimes I see guys don't look much older than me—

MAMA Son—how come you talk so much 'bout money?

WALTER (*With immense passion*) Because it is life, Mama!

MAMA (*Quietly*) Oh—(*Very quietly*) So now it's life. Money is life. Once upon a time freedom used to be life—now it's money. I guess the world really do change . . .

WALTER No—it was always money, Mama. We just didn't know about it.

RETURN OF THE NATIVE
IMAMU AMIRI BARAKA (LEROI JONES)

Harlem is vicious
modernism. BangClash.
Vicious the way it's made.
Can you stand such beauty?
So violent and transforming.
The trees blink naked, being
so few. The women stare
and are in love with them
selves. The sky sits awake
over us. Screaming
at us. No rain.
Sun, hot cleaning sun
drives us under it.

The place, and place
meant of
black people. Their heavy Egypt.
(Weird word!) Their minds, mine,
the black hope mine. In Time.
We slide along in pain or too
happy. So much love
for us. All over, so much of
what we need. Can you sing
yourself, your life, your place
on the warm planet earth.
And look at the stones

the hearts, the gentle hum
of meaning. Each thing, life
we have, or love, is meant
for us in a world like this.
Where we may see ourselves
all the time. And suffer
in joy, that our lives
are so familiar.

SPECTRUM
MARI EVANS

Petulance is purple
happiness pink
ennui chartreuse
and love
—I think
is blue
like midnight sometimes
or a robin's egg
sometimes

WHERE HAVE YOU GONE
MARI EVANS

Where have you gone

with your confident
walk with
your crooked smile

why did you leave
me
when you took your
laughter
and departed

are you aware that
with you
went the sun
all light
and what few stars
there were?

where have you gone
with your confident
walk your
crooked smile the
rent money
in one pocket and
my heart
in another . . .

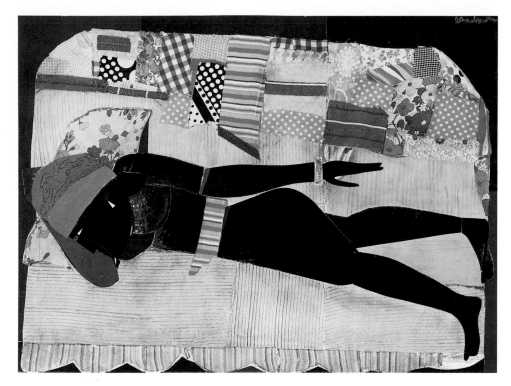

Patchwork Quilt, Romare Bearden, 1970
Patchwork can bring all kinds of things together.

poem at thirty

SONIA SANCHEZ

it is midnight
no magical bewitching
hour for me
i know only that
i am here waiting
remembering that
once as a child
i walked two
miles in my sleep.
did i know
then where i
was going?
traveling. i'm
always traveling.
i want to tell
you about me
about nights on a
brown couch when
i wrapped my
bones in lint and
refused to move.
no one touches
me anymore.
father do not
send me out
among strangers.
you you black man
stretching scraping
the mold from your body.
here is my hand.
i am not afraid
of the night.

MARROW OF MY BONE

MARI EVANS

Fondle me
caress
and cradle
me
with your lips
withdraw
the nectar from
me
teach me there
is
someone

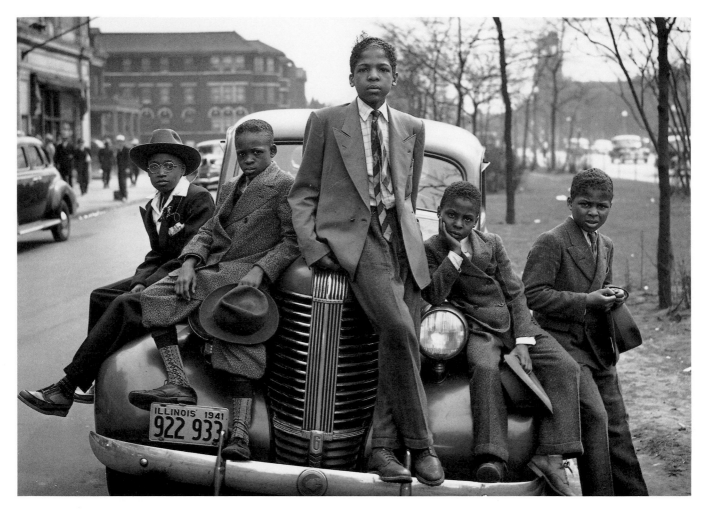

Negro Boys on Easter Morning on the South Side of Chicago, photograph by Russell Lee, April 1941
In the 1940s, it seemed impossible that an African American could ever be president.

CHILDREN'S RHYMES

LANGSTON HUGHES

By what sends
the white kids
I ain't sent:
I know I can't
be President.

What don't bug
them white kids
sure bugs me:
We know everybody
ain't free.

Lies written down
for white folks
ain't for us a-tall:
Liberty And Justice —
Huh! — *For All?*

LOVE REJECTED

LUCILLE CLIFTON

Love rejected
hurts so much more
than Love rejecting;
they act like they don't love their country
No
what it is
is they found out
their country don't love them.

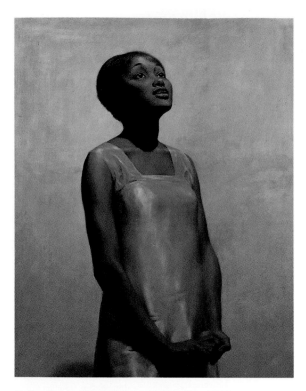

Ruby Green Singing, James Chapin, 1928

LISTEN, LORD—A PRAYER

JAMES WELDON JOHNSON

O Lord, we come this morning
Knee-bowed and body-bent
Before thy throne of grace.
O Lord—this morning—
Bow our hearts beneath our knees,
And our knees in some lonesome valley.
We come this morning—
Like empty pitchers to a full fountain,
With no merits of our own.
O Lord—open up a window of heaven,
And lean out far over the battlements of glory,
And listen this morning.

Lord, have mercy on proud and dying sinners—
Sinners hanging over the mouth of hell,
Who seem to love their distance well.
Lord—ride by this morning—
Mount your milk-white horse,
And ride-a this morning—
And in your ride, ride by old hell,
Ride by the dingy gates of hell,
And stop poor sinners in their headlong plunge.

And now, O Lord, this man of God,
Who breaks the bread of life this morning—
Shadow him in the hollow of thy hand,
And keep him out of the gunshot of the devil.
Take him, Lord—this morning—
Wash him with hyssop inside and out,
Hang him up and drain him dry of sin.
Pin his ear to the wisdom-post,
And make his words sledge hammers of truth—
Beating on the iron heart of sin.

Lord God, this morning—
Put his eye to the telescope of eternity,
And let him look upon the paper walls of time.
Lord, turpentine his imagination,
Put perpetual motion in his arms,
Fill him full of the dynamite of thy power,
Anoint him all over with the oil of thy salvation,
And set his tongue on fire.

And now, O Lord—
When I've done drunk my last cup of sorrow—
When I've been called everything but a child of God—
When I'm done travelling up the rough side of the
 mountain—
O—Mary's Baby—
When I start down the steep and slippery steps of death—
When this old world begins to rock beneath my feet—
Lower me to my dusty grave in peace
To wait for that great gittin' up morning—Amen.

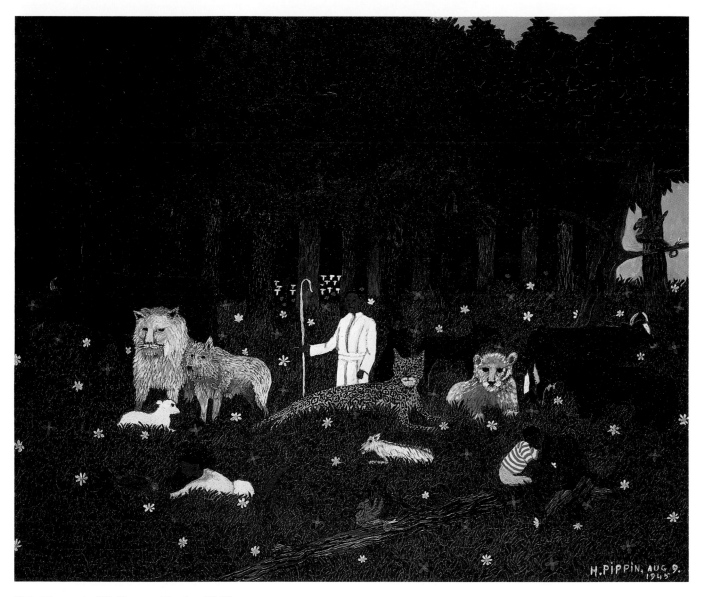

Holy Mountain III, Horace Pippin, 1945

THE LORD IS MY SHEPHERD

(THE 23RD PSALM)

The Lord is my shepherd; I shall not want.
He maketh me to lie down in green pastures:
 he leadeth me beside the still waters.
He restoreth my soul: he leadeth me in the
 paths of righteousness for his name's sake.

Yea, though I walk through the valley of the
 shadow of death, I will fear no evil: for
 thou art with me; thy rod and thy staff
 they comfort me.
Thou preparest a table before me, in the
 presence of mine enemies: thou anointest
 my head with oil; my cup runneth over.
Surely goodness and mercy shall follow me
 all the days of my life: and I will dwell
 in the house of the Lord for ever.

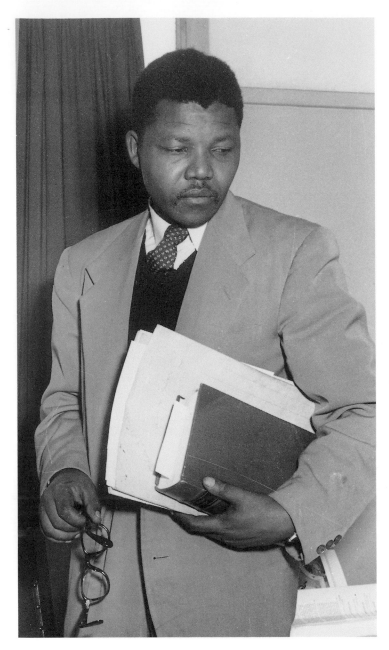

Nelson Mandela in Johannesburg, South Africa,
photograph by Jurgen Schadeberg, 1952
A world leader as he looked near the beginning
of his great struggle against racism.

HOW CAN I LOSE HOPE

from SING A SOFTBLACK POEM

KWELISMITH

For Winnie Mandela

Sing a softblack poem fora
softblack sistah to lay her
head on

Nomzamo
Nomzamo Winnie Mandela
Nomzamo
Nomzamo Winnie Mandela

courageous
outspoken unbroken
rock me in yo circles
tie-dyed purpleorange
yellowgreen blue blended
range squeezed in the same
time blended where she
carries her babies she
carries her music she
carries her people
rich fertile womb
floods her lips

How can I lose hope
when I know
this country is ours

Governor Lawrence Douglas Wilder of Virginia,
photograph by D. D. Galyeau, 1990

One of a new generation of American leaders
who speak out on the important issues.

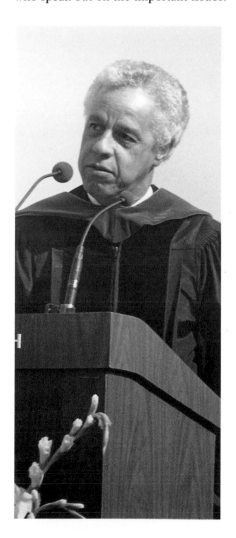

QUESTION AND ANSWER

LANGSTON HUGHES

Durban, Birmingham,
Cape Town, Atlanta,
Johannesburg, Watts,
The earth around
Struggling, fighting,
Dying—for what?

A world to gain.

Groping, hoping,
Waiting—for what?

A world to gain.

Dreams kicked asunder,
Why not go under?

There's a world to gain.

But suppose I don't want it,
Why take it?

To remake it.

Jesse Jackson, photographer unknown,
about 1970

A leading candidate for the presidency
of the United States in 1988.

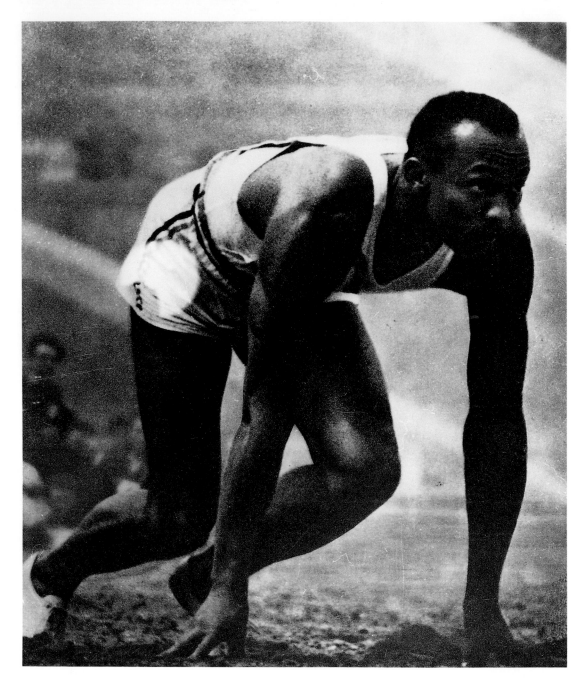

Jesse Owens in the Olympic Games, photograph by Leni Riefenstahl, Berlin, 1936

The first African American to compete in the Olympics, he won four gold medals and was hailed as a great athlete.

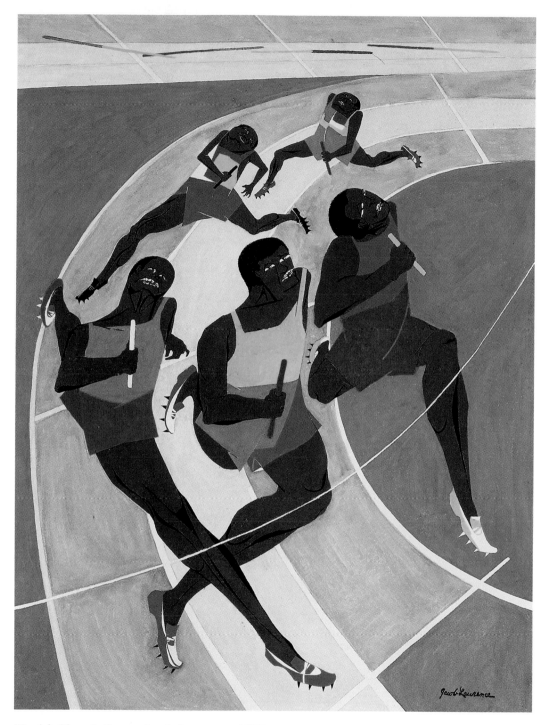

DIG YOUR STARTING HOLES DEEP

from TO JAMES

FRANK HORNE

Dig your starting holes
deep and firm
lurch out of them
into the straightaway
with all the power
that is in you
look straight ahead
to the finish line
think only of the goal
run straight
run high
run hard
save nothing
and finish
with an ecstatic burst
that carries you
hurtling
through the tape
to victory

Munich Olympic Games, Jacob Lawrence, 1971
Finish of a relay race, in which each runner carries the baton of his team.

STRONG MEN

STERLING A. BROWN

The strong men keep coming on.
 — SANDBURG

They dragged you from homeland,
They chained you in coffles,
They huddled you spoon-fashion in filthy hatches,
They sold you to give a few gentlemen ease.

They broke you in like oxen,
They scourged you,
They branded you,
They made your women breeders,
They swelled your numbers with bastards....
They taught you the religion they disgraced.

You sang:
 Keep a-inchin' along
 Lak a po' inch worm....

You sang:
 Bye and bye
 I'm gonna lay down dis heaby load....

You sang:
 Walk togedder, chillen,
 Dontcha git weary....
 The strong men keep a-comin' on
 The strong men git stronger.

They point with pride to the roads you built for them,
They ride in comfort over the rails you laid for them.
They put hammers in your hands
And said — Drive so much before sundown.

You sang:
 Ain't no hammah
 In dis lan',
 Strikes lak mine, bebby,
 Strikes lak mine.

They cooped you in their kitchens,
They penned you in their factories,
They gave you the jobs that they were too
 good for,
They tried to guarantee happiness to themselves
By shunting dirt and misery to you.

You sang:
 Me an' muh baby gonna shine, shine
 Me an' muh baby gonna shine.
 The strong men keep a-comin' on
 The strong men git stronger....

They bought off some of your leaders
You stumbled, as blind men will....
They coaxed you, unwontedly soft-voiced....
You followed a way.
Then laughed as usual.
They heard the laugh and wondered;
Uncomfortable;
Unadmitting a deeper terror....
 The strong men keep a-comin' on
 Gittin' stronger....

What, from the slums
Where they have hemmed you,
What, from the tiny huts
They could not keep from you —
What reaches them
Making them ill at ease, fearful?
Today they shout prohibition at you
"Thou shalt not this"
"Thou shalt not that"
"Reserved for whites only"
You laugh.

One thing they cannot prohibit —
 The strong men ... coming on
 The strong men gittin' stronger.
 Strong men....
 Stronger....

FOR MY PEOPLE

MARGARET WALKER

For my people everywhere singing their slave songs repeatedly: their
 dirges and their ditties and their blues and jubilees, praying
 their prayers nightly to an unknown god, bending their knees
 humbly to an unseen power;

For my people lending their strength to the years, to the gone years and
 the now years and the maybe years, washing ironing cooking
 scrubbing sewing mending hoeing plowing digging planting
 pruning patching dragging along never gaining never reaping
 never knowing and never understanding;

For my playmates in the clay and dust and sand of Alabama backyards
 playing baptizing and preaching and doctor and jail and soldier
 and school and mama and cooking and playhouse and concert
 and store and hair and Miss Choomby and company;

For the cramped bewildered years we went to school to learn to know the
 reasons why and the answers to and the people who and the
 places where and the days when, in memory of the bitter hours
 when we discovered we were black and poor and small and dif-
 ferent and nobody cared and nobody wondered and nobody
 understood;

For the boys and girls who grew in spite of these things to be man and
 woman, to laugh and dance and sing and play and drink their
 wine and religion and success, to marry their playmates and
 bear children and then die of consumption and anemia and
 lynching;

For my people thronging 47th Street in Chicago and Lenox Avenue in
 New York and Rampart Street in New Orleans, lost disinherited
 dispossessed and happy people filling the cabarets and taverns
 and other people's pockets needing bread and shoes and milk
 and land and money and something—something all our own;

For my people walking blindly spreading joy, losing time being lazy,
 sleeping when hungry, shouting when burdened, drinking
 when hopeless, tied and shackled and tangled among ourselves
 by the unseen creatures who tower over us omnisciently and
 laugh;

For my people blundering and groping and floundering in the dark of
churches and schools and clubs and societies, associations and
councils and committees and conventions, distressed and dis-
turbed and deceived and devoured by money-hungry glory-
craving leeches, preyed on by facile force of state and fad and
novelty, by false prophet and holy believer;

For my people standing staring trying to fashion a better way from con-
fusion, from hypocrisy and misunderstanding, trying to fashion
a world that will hold all the people, all the faces, all the adams
and eves and their countless generations;

Let a new earth rise. Let another world be born. Let a bloody peace be
written in the sky. Let a second generation full of courage issue
forth; let a people loving freedom come to growth. Let a beauty
full of healing and a strength of final clenching be the pulsing in
our spirits and our blood. Let the martial songs be written, let
the dirges disappear. Let a race of men now rise and take control.

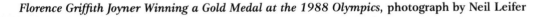

Florence Griffith Joyner Winning a Gold Medal at the 1988 Olympics, photograph by Neil Leifer

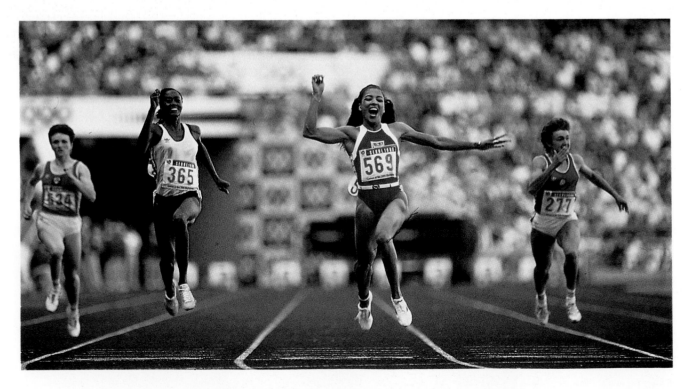

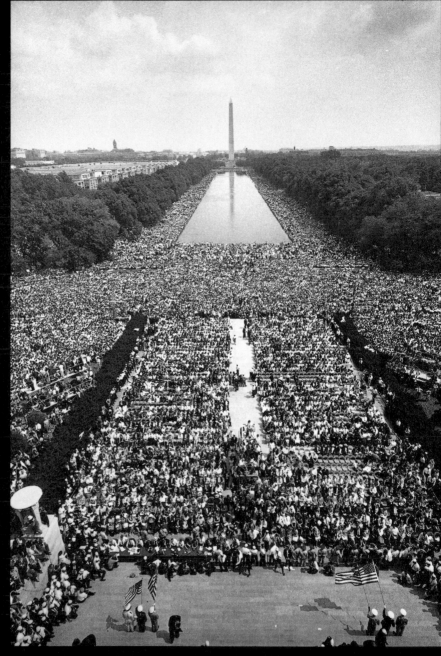

The March on Washington, photograph by Fred Ward, August 28, 1963

HOW MANY TIMES?

from BLOWIN' IN THE WIND
Song lyrics, 1963

BOB DYLAN

How many times can a man turn his head,
pretending he just doesn't see?
The answer, my friend, is blowin' in the wind,
the answer is blowin' in the wind.

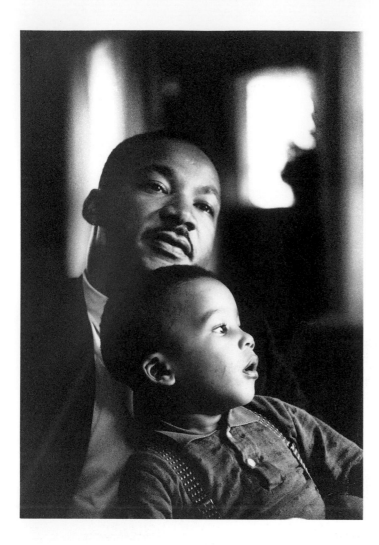

I HAVE A DREAM

from a speech by Martin Luther King, Jr., at the Lincoln Memorial,
Washington, D.C., August 28, 1963

I say to you today, my friends, so even though we face the difficulties of
today and tomorrow, I still have a dream. It is a dream deeply rooted in
the American meaning of its creed, "We hold these truths to be self-
evident, that all men are created equal." I have a dream that one day on
the red hills of Georgia, sons of former slaves and the sons of former
slave owners will be able to sit down together at the table of brotherhood.
I have a dream that one day even the state of Mississippi, a state sweltering
with the heat of injustice, sweltering with the heat of oppression,
will be transformed into an oasis of freedom and justice. I have a dream
that my four little children will one day live in a nation where they will not
be judged by the color of their skin, but the content of their character.

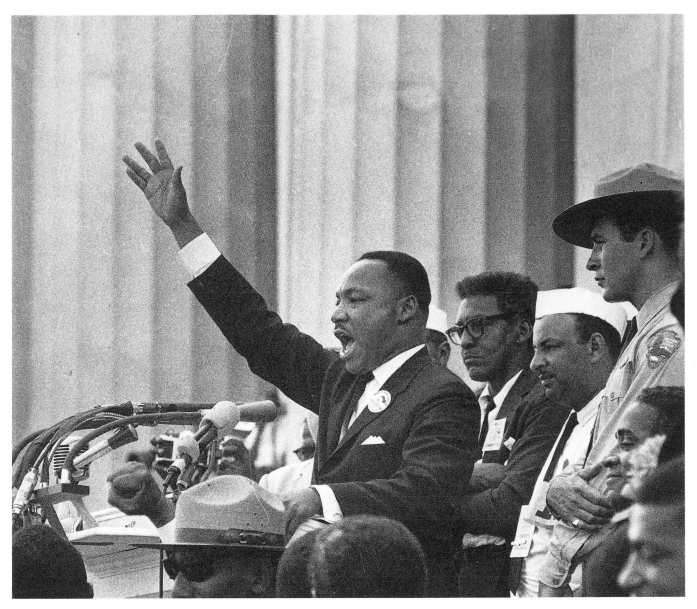

Martin Luther King, Jr., Giving His "I Have a Dream" Speech, photograph by Bob Adelman, August 28, 1963, at the Lincoln Memorial, Washington, D.C.

ALABAMA CENTENNIAL

NAOMI MADGETT

They said, "Wait." Well, I waited.
For a hundred years I waited
In cotton fields, kitchens, balconies,
In bread lines, at back doors, on chain gangs,
In stinking "colored" toilets
And crowded ghettos,
Outside of schools and voting booths.
And some said, "Later."
And some said, "Never!"

Then a new wind blew, and a new voice
Rode its wings with quiet urgency,
Strong, determined, sure.
"No," it said. "Not 'never,' not 'later,'
Not even 'soon.'
Now.
Walk!"

And other voices echoed the freedom words,
"Walk together, children, don't get weary,"
Whispered them, sang them, prayed them, shouted them.
"Walk!"
And I walked the streets of Montgomery
Until a link in the chain of patient acquiescence broke.

Then again: Sit down!
And I sat down at the counters of Greensboro.
Ride! And I rode the bus for freedom.
Kneel! And I went down on my knees in prayer and faith.
March! And I'll march until the last chain falls
Singing, "We shall overcome."

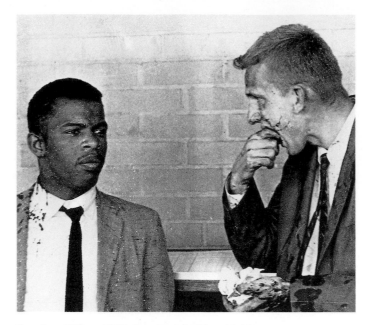

Freedom Riders, UPI photograph, May 1961
John Lewis and Jim Zwerg, two of the young Americans who
integrated buses in the South during the 1960s.

Not all the dogs and hoses in Birmingham
Nor all the clubs and guns in Selma
Can turn this tide.
Not all the jails can hold these young black faces
From their destiny of manhood,
Of equality, of dignity,
Of the American Dream
A hundred years past due.
Now!

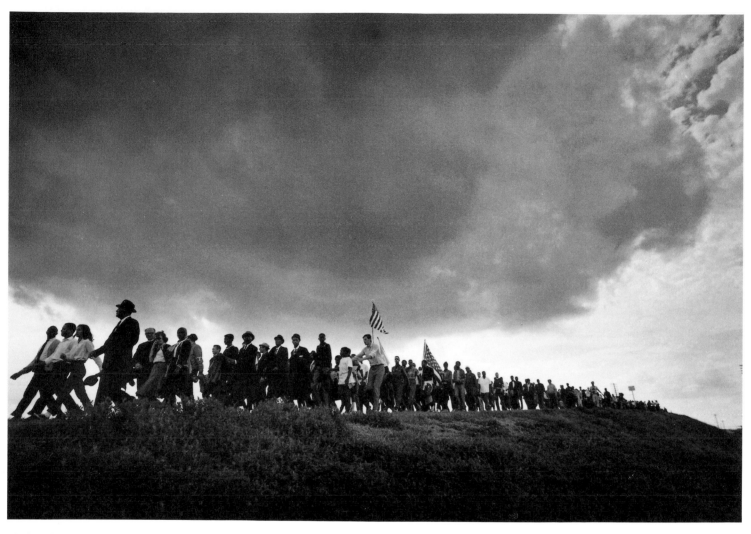

Civil Rights March from Selma to Montgomery, Alabama, photograph by James Karales, March 21, 1965

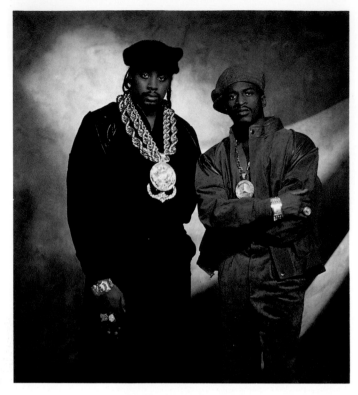

Rappers: Eric B. and Rakim, photograph by Cesar Vern, 1989

PEOPLE OF GLEAMING CITIES, AND OF THE LION'S AND THE LEOPARD'S BROOD

SHARON BOURKE

We have never stopped being Africans;
Speaking, minus our tongues,
With the drums of mental telepathy;
Planting, minus our whole seed,
The flowering cuttings of tribalness;
Wanting, minus hills and rivers that know us,
A land once more
Of leopard's boldness and lion's pride.
We have never stopped wearing the life masks of ancestors
Who, through us, gaze out over all human time.
For a long while we have brewed in our heart memory's herbs,
Prepared the drink of peoplehood.
We have never stopped being what we have preserved.
And now we flourish.

WHAT IS AFRICA TO ME?

from HERITAGE

COUNTEE CULLEN

Africa? A book one thumbs
Listlessly, till slumber comes.
Unremembered are her bats
Circling through the night, her cats
Crouching in the river reeds,
Stalking gentle flesh that feeds
By the river brink; no more
Does the bugle-throated roar
Cry that monarch claws have leapt
From the scabbards where they slept.
Silver snakes that once a year
Doff the lovely coats you wear,
Seek no covert in your fear
Lest a mortal eye should see;
What's your nakedness to me?
Here no leprous flowers rear
Fierce corollas in the air;
Here no bodies sleek and wet,
Dripping mingled rain and sweat,
Tread the savage measures of
Jungle boys and girls in love.
What is last year's snow to me,
Last year's anything? The tree
Budding yearly must forget
How its past arose or set—
Bough and blossom, flower, fruit,
Even what shy bird with mute
Wonder at her travail there,
Meekly labored in its hair.
One three centuries removed
From the scenes his fathers loved,
Spicy grove, cinnamon tree,
What is Africa to me?

Feles for Sale, Charles Searles, 1972
Seen by the artist during a visit to Nigeria,
these brightly woven skullcaps are sold in
marketplaces throughout Africa.

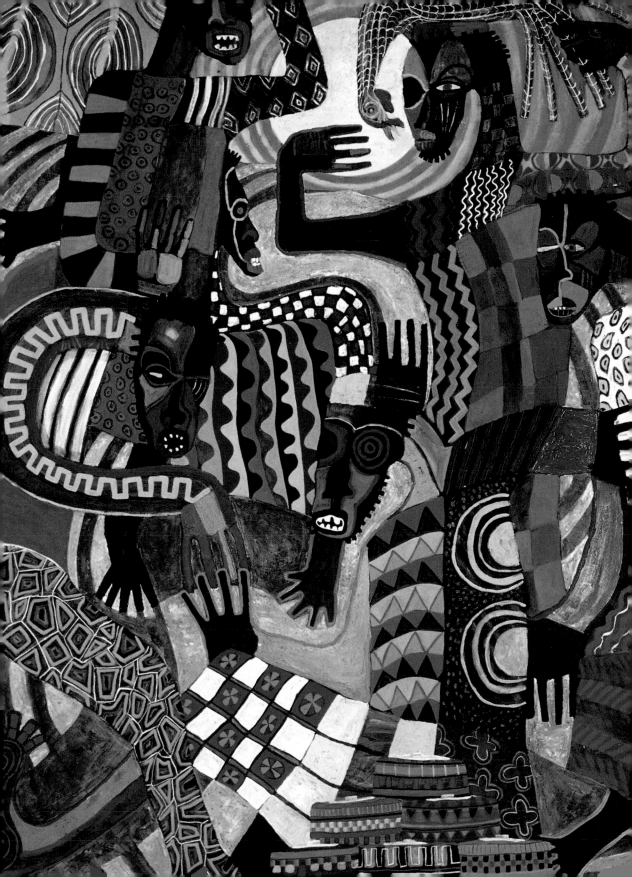

KA 'BA

IMAMU AMIRI BARAKA (LEROI JONES)

A closed window looks down
on a dirty courtyard, and black people
call across or scream across or walk across
defying physics in the stream of their will

Our world is full of sound
Our world is more lovely than anyone's
tho we suffer, and kill each other
and sometimes fail to walk the air

We are beautiful people
with african imaginations
full of masks and dances and swelling chants
with african eyes, and noses, and arms,
though we sprawl in grey chains in a place
full of winters, when what we want is sun.

We have been captured,
brothers. And we labor
to make our getaway, into
the ancient image, into a new

correspondence with ourselves
and our black family. We need magic
now we need the spells, to raise up
return, destroy, and create. What will be

the sacred words?

Welcome to My Ghetto Land, Jean Lacy, 1986

MAMMA SETTLES THE DROPOUT PROBLEM

BETTY GATES

Lawd, Son, whut um go do with you?
You makes me so mad
I don' know whut to do!
You thinks you's a man
And I hope one day you'll be,
But you got 'bout enuff
Sense to stuff a skinny flea!
Done worked myself until
Um nelly 'bout dead
So as you can go to school
An' git sumthin in yo head,
An' you come tellin me
That you gon' quit
Cause they aint got
Whut you wanna git.
Well, they sho is got
Much mo'n you
An' if you don' git it
Dis whut um go do:
Um goin' up side yo head
Wit my big fiss
An' when I swings
I don' aim to miss!

I done talked an' talked
Tell my face is blue,
Still I cain' talk
No sense in you.
Talkin' bout you
So proud you black,
If you wuz you'd
Know how to ack!
A heap a folks
Done went through hell,
Marchin' in the streets
An' goin' to jail;
An' some mighty good folks
Is laying up dead
Jes so you can
Fill yo empty head.
Now, you gon' stop
Yo ackin lak a fool!
You git yo books
An' you git back to school!

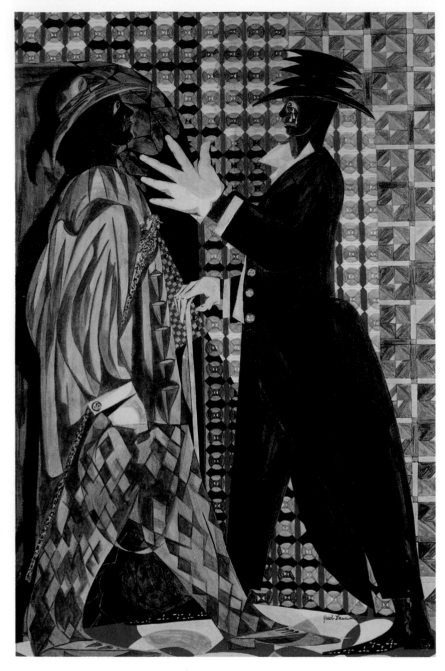

Vaudeville, Jacob Lawrence, 1951

In the old days, some people were afraid to say what they really thought and felt.

LAUGHERS

LANGSTON HUGHES

Dream singers,
Story tellers,
Dancers,
Loud laughers in the hands of Fate —
 My people.
Dish-washers,
Elevator-boys,
Ladies' maids,
Crap-shooters,
Cooks,
Waiters,
Jazzers,
Nurses of babies,
Loaders of ships,
Rounders,
Number writers,
Comedians in vaudeville
And band-men in circuses —
Dream-singers all, —
 My people.
Story-tellers all, —
 My people.
 Dancers —
God! What dancers!
 Singers —
God! What singers!
Singers and dancers.
Dancers and laughers.
 Laughers?
Yes, laughers . . . laughers . . . laughers —
Loud-mouthed laughers in the hands
 Of Fate.

TO THOSE OF MY SISTERS
WHO KEPT THEIR NATURALS

GWENDOLYN BROOKS

Never to look a hot-comb in the teeth.

Sisters!
I love you
Because you love you.
Because you are erect.
Because you are also bent.
In season, stern, kind.
Crisp, soft. In season.
And you withhold.
And you extend.
And you step out.
And you go back.
And you extend again.
Your eyes, loud-soft, with crying and with smiles,
are older than a million years.
And they are young.
You reach, in season.
You subside, in season.
And All
below the richrough righttime of your hair.

You have not bought Blondine.
You have not hailed the hot-comb recently.
You never worshiped Marilyn Monroe.
You say: Farrah's hair is hers.
You have not wanted to be white.
Nor have you testified to adoration of that state
with the advertisement of imitation
(*never* successful because the hot-comb is laughing too).

But oh the rough dark Other music.
the Real,
the Right;
the natural Respect of Self and Seal.
 Sisters.
Your hair is Celebration in the world.

WE WEAR THE MASK
PAUL LAURENCE DUNBAR

We wear the mask that grins and lies,
It hides our cheeks and shades our eyes,—
This debt we pay to human guile;
With torn and bleeding hearts we smile,
And mouth with myriad subtleties.

Why should the world be overwise,
In counting all our tears and sighs?
Nay, let them only see us, while
 We wear the mask.

We smile, but, O great Christ, our cries
To Thee from tortured souls arise.
We sing, but oh, the clay is vile
Beneath our feet, and long the mile;
But let the world dream otherwise,
 We wear the mask.

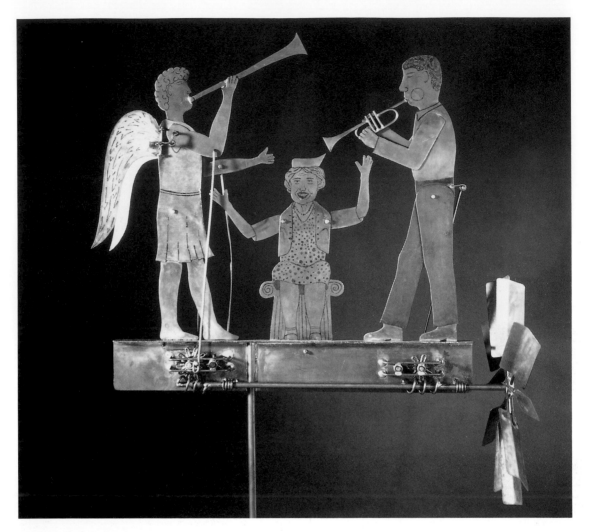

Wind Machine with Gabriel,
Eleanor Roosevelt, and Louis Armstrong,
James Leonard, 1984

OLD SATCHMO'S GRAVELLY VOICE

from SATCHMO

MELVIN B. TOLSON

Old Satchmo's
gravelly voice and tapping foot and crazy notes
set my soul on fire.
If I climbed
the seventy-seven steps of the Seventh
Heaven, Satchmo's high C would carry me higher!
Are you hip to this, Harlem? Are you hip?
On Judgment Day, Gabriel will say
after he blows his horn:
"I'd be the greatest trumpeter in the Universe,
if old Satchmo had never been born!"

TO THE YOUNG WHO WANT TO DIE

GWENDOLYN BROOKS

Sit down. Inhale. Exhale.
The gun will wait. The lake will wait.
The tall gall in the small seductive vial
will wait will wait:
will wait a week: will wait through April.
You do not have to die this certain day.
Death will abide, will pamper your postponement.
I assure you death will wait. Death has
a lot of time. Death can
attend to you tomorrow. Or next week. Death is
just down the street; is most obliging neighbor;
can meet you any moment.

You need not die today.
Stay here—through pout or pain or peskyness.
Stay here. See what the news is going to be tomorrow.

Graves grow no green that you can use.
Remember, green's your color. You are Spring.

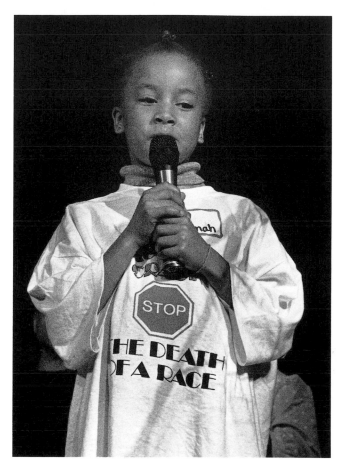

A Girl Urges Her Friends to Help "Stop the Death of a Race,"
photograph by George T. Kruse, 1989
At a conference of concerned families in San Francisco.

Following are brief biographical notes about the writers and artists, most of them African Americans, whose work appears in this book (or who are subjects of illustrations therein). Every effort has been made to achieve accuracy, but in some cases two or more sources gave different information about such matters as date or place of birth.

ADAMS, JOHN HENRY, JR. Artist who published drawings in *Voice of the Negro,* a magazine of the early 1900s.

BALDWIN, JAMES (1924–1987). Born in New York. Influential writer whose books include *Go Tell It on the Mountain* (1953) and *The Fire Next Time* (1963).

BANNEKER, BENJAMIN (1731–1806). Born in Maryland. Self-educated mathematician and scientist; worked for the D.C. Survey Commission—probably the first federal government employee of African ancestry.

BARAKA, IMAMU AMIRI (born 1934). Born in New Jersey. Writer and college professor, previously known as LeRoi Jones. Books include the anthology *Black Poetry 1961–1967.*

BEARDEN, ROMARE (1911–1988). Born in North Carolina. Famous artist best known for collages (creative combinations of different materials). Strongly influenced by his love of music.

BELLOWS, GEORGE WESLEY (1882–1925). Born in Ohio. Artist whose scenes of sports and other events won many prizes.

BENTON, THOMAS HART (1889–1975). Born in Missouri. Artist specializing in murals and paintings of rural life in the Middle West and other regional settings.

BONTEMPS, ARNA (1902–1973). Born in Louisiana. Poet and writer on black history and related topics; librarian at Fisk University, Nashville, Tennessee.

BOURKE, SHARON. Born in New York. Contemporary editor and writer whose poems have appeared in a variety of publications.

BROOKS, GWENDOLYN (born 1917). Born in Kansas, lives in Chicago. Celebrated poet who received the Pulitzer Prize in 1950. Author of *Selected Poems* (1963) and many other books.

BROWN, JOHN GEORGE (1831–1913). English artist who moved to America; became very popular for his paintings of everyday life.

BROWN, STERLING A. (1901–1989). Born in Washington, D.C. Poet, critic, college professor. *Collected Poems* (1980) reflects his many years of effort to develop an African-American folk literature.

BRUCE, RICHARD (1906–1987). Born in Washington, D.C. One of several names used by Richard Bruce Nugent to conceal his "Bohemian" life as writer and painter from his more conservative relatives and friends.

CARVER, GEORGE WASHINGTON (about 1864–1943). Born in Missouri. Scientist, college professor. His discoveries made it possible for Southern farmers to grow and market a wider variety of crops, thus weakening the grip of "King Cotton."

CHAPIN, JAMES (1887–about 1950). Born in New Jersey. Artist whose scenes of American life are included in many collections.

CLIFTON, LUCILLE (born 1936 in New York). College professor and poet whose books include *Good Times* (1969) and *Next: New Poems* (1987). Also writes for children.

COPLEY, JOHN SINGLETON (1738–1815). Born in Massachusetts. Painter who achieved great success with portraits in the American colonies and later in England.

CULLEN, COUNTEE (1903–1946). Born in New York. Poet, teacher. Author of many books of stories and verse, including *Copper Sun* (1927), *One Way to Heaven* (1932), and *On These I Stand* (1947).

DANNER, MARGARET (born 1915 in Illinois). Award-winning poet with strong interest in African heritage. Wrote *Iron Lace* (1968) and other books. Also a gifted speaker and reader of poetry.

DEGAS, EDGAR (1834–1917). Celebrated French artist who visited relatives in New Orleans, 1872–73, and worked on several paintings there.

DOUGLASS, FREDERICK (about 1817–1895). Born in Maryland. Escaped from slavery in 1838, wrote and lectured about abolition, strongly believed in equal rights for all.

DU BOIS, W. E. B. (1868–1963). Born in Massachusetts. Influential reformer and college professor who wrote twenty-one books, received many awards and honors.

DUNBAR, PAUL LAURENCE (1872–1906). Born in Ohio. Wrote many books of fiction and poetry, starting with *Oak and Ivy* (1893) and *Majors and Minors* (1895).

DYLAN, BOB (born 1941 in Minnesota). Songwriter, singer with many styles and subjects. Entered the Rock and Roll Hall of Fame in 1988.

EAKINS, THOMAS (1844–1916). Born in Pennsylvania. Controversial painter, photographer, and teacher whose portraits are prized more for their honesty than for their beauty.

EQUIANO, OLAUDAH (1745–about 1801). Also known as Gustavus Vassa. Born in Nigeria, enslaved, bought his freedom in 1766, and led an adventurous life.

ERIC B. Contemporary "rap" performer who has recorded *Paid in Full* and other albums with his partner, **RAKIM.**

EVANS, MARI. Currently living and working in Indiana. Poet, television producer, college professor, winner of many awards. Her books include *I Am a Black Woman* (1970), *Nightstar* (1981), and *A Dark and Splendid Mass* (1991).

FISHER, RUDOLPH (1897–1934). Born in Washington, D.C. Short story writer, novelist, doctor of medicine. Books include *The Walls of Jericho* (1928) and *The Conjure Man Dies* (1932).

FORTUNE, AMOS. His headstone says: "Born free in Africa, a slave in America, he purchased liberty, professed Christianity, lived reputably, and died hopefully. Nov. 17, 1801, age 91."

FORTUNE, VIOLATE. Her headstone says: "By sale the slave of Amos Fortune, by Marriage his wife, by her fidelity his friend and solace, she died his widow. Sept. 13, 1802, age 73."

FOSTER, STEPHEN COLLINS (1826–1864). Born in Pennsylvania. Wrote some of America's favorite songs but lived unwisely and died in poverty.

FULLER, META VAUX WARWICK (1877–1968). Born in Pennsylvania. Sculptor whose beautiful bronzes show the influence of her studies with Rodin and others in Europe.

GATES, BETTY. Contemporary poet whose work has appeared in several periodicals; also a college professor.

GIBSON, CHARLES DANA (1867–1944). Born in Massachusetts. Author, illustrator, artist whose "Gibson Girls" set a standard of feminine beauty in white society at the turn of the century.

GIOVANNI, NIKKI (born 1943 in Tennessee). Award-winning writer, college professor, who writes, reads, records, and teaches poetry. Books include *Black Judgment* (1968), *My House* (1972), and *Those Who Ride the Night Wind* (1983).

GRIFFITH JOYNER, FLORENCE (born 1959 in California). Called "the world's fastest woman," she won four medals at the 1988 Olympics; also received the Jesse Owens Award as that year's outstanding track-and-field athlete.

GWATHMEY, ROBERT (1903–1988). Born in Virginia. Prizewinning painter whose strongly drawn scenes of Southern life are found in numerous art collections.

HAMMERSTEIN, OSCAR, II (1895–1960). Born in New York. Wrote song lyrics for many Broadway hits, such as *Oklahoma!* (1943) and *South Pacific* (1949), both of which won Pulitzer Prizes.

HANSBERRY, LORRAINE (1930–1965). Born in Illinois. Playwright who wrote *A Raisin in the Sun* (1958), which was highly successful, and other plays. Her brief career held great promise.

HARPER, FRANCES E. W. (1825–1911). Born in Baltimore of free parents, she became a crusader against slavery. Books include *Sketches of Southern Life* (1872) and *Poems* (1900).

HAYDEN, PALMER COLE (1890–1973). Born in Virginia. Artist specializing in rural and urban paintings of African Americans.

HAYDEN, ROBERT E. (1913–1980). Born in Michigan. Insisted on being judged as a poet, regardless of race; gradually received wide recognition with *Selected Poems* (1966) and *Angle of Ascent* (1975).

HENDRIX, JIMI (James Marshall) (1942–1970). Born in Seattle, Washington. Popular musician and winner of many awards; his songs and guitar techniques had great influence on rock and soul music.

HESSELIUS, JOHN (1728–1778). American artist of Swedish descent who painted many portraits of colonial people in Maryland.

HINE, LEWIS WICKES (1879–1940). Born in Wisconsin. Photographer who focused on the need for social reforms in child labor, housing of the poor, and other areas.

HOMER, WINSLOW (1836–1910). Born in Massachusetts. Magazine illustrator who later achieved fame for his paintings of nature and scenes of everyday life in America.

HORNE, FRANK (1899–1974). Born in New York. Educator, government official, poet, with early interests in running, writing. *Haverstraw* (1963) is a collection of his pieces.

HOWE, JULIA WARD (1819–1910). Born in New York. Reformer who pursued goals such as women's rights and world peace through her lectures and books.

HUGHES, LANGSTON (1902–1967). Born in Missouri, lived in New York and elsewhere. Writer whose books of poetry, starting with *The Weary Blues* (1926) and *The Dream Keeper* (1932), have inspired others to write.

HURN, JOHN W. (1860–about 1920). American photographer whose work has not gained wide recognition.

ISAAC (about 1775–1849). Born in Virginia. Worked for Thomas Jefferson; unable to read or write, he dictated to Charles Campbell his *Memoirs of a Monticello Slave* (1847).

JACKSON, JESSE (born 1941 in South Carolina). Clergyman, civic leader; candidate for the Democratic party's nomination for the presidency of the United States in 1984 and 1988.

JEFFERSON, THOMAS (1743–1826). Born in Virginia. Third president of the United States (1801–9); earlier he expressed American resistance to British rule in the Declaration of Independence (1776), which says that "all men are created equal."

JOCELYN, NATHANIEL (1796–1881). Born in Connecticut. Worked as an engraver before becoming a portrait painter.

JOHNSON, EASTMAN (1824–1906). Born in Maine. Northern artist whose scenes of Southern life were extremely popular.

JOHNSON, JAMES WELDON (1871–1938). Born in Florida. Lawyer, diplomat, writer, college professor, NAACP official. Poetry books include *Black Manhattan* (1930) and *Along This Way* (1933).

JOHNSON, SARGENT CLAUDE (1889–1967). Born in Massachusetts. Artist whose portrayals of African Americans are displayed by leading museums in California and elsewhere.

JOHNSON, WILLIAM H. (1901–1970). Painter who won fame here and abroad for his expressionist scenes of African Americans in farm, prison, war, and religious settings.

JOHNSTON, FRANCES BENJAMIN (1864–1952). Born in West Virginia. Adventurous photographer best known for her striking pictures of unposed people in all walks of life.

JONES, ABSALOM (1746–1818). Born a slave in Delaware, he educated himself, bought his freedom, became a church leader in Philadelphia. After the American Revolution, he and others persuaded the newly established government of the United States to abolish the African slave trade.

KING, MARTIN LUTHER, JR. (1929–1968). Born in Georgia. Outstanding spokesman for human equality who believed in nonviolent action by masses of people. Received numerous awards, including the Nobel Peace Prize (1964).

KNIGHT, CURTIS. Contemporary soul singer who composed and recorded songs with Jimi Hendrix and later wrote a biography of him.

KWELISMITH. Contemporary poet who lives in Washington, D.C. Her work includes *Slavesong* (1989).

LACY, JEAN (born 1932 in Washington, D.C.). Artist and museum education specialist; she says: "I relate to ancient forms, images and monuments."

LATROBE, BENJAMIN HENRY (1764–1820). English-born engineer and architect who worked on many buildings in the United States, including several designed by Thomas Jefferson.

LAWRENCE, JACOB (born 1917 in New Jersey). World-famous artist whose work is displayed in many exhibitions and museums.

LAWSON, ERNEST (1873–1939). Born in California. Prizewinning artist who liked to use bold, bright colors in paintings.

LEE, RUSSELL W. (1903–1986). Born in Illinois. Best known for his photographs of life in the Middle West during the Depression of the 1930s.

L'ENFANT, PIERRE-CHARLES (1754–1825). Came from France to fight in the American Revolution; a designer whose plan for the District of Columbia was considered too advanced by some.

LEONARD, JAMES (born 1949 in New Jersey). Cabinetmaker and woodworker who creates works of art as a hobby.

LINCOLN, ABRAHAM (1809–1865). Born in Kentucky. Sixteenth president of the United States (1861–65). Ended slavery in the Confederate states and led the Union to victory in the Civil War.

LOWELL, ROBERT (1917–1977). Poet and translator; awarded the Pulitzer Prize in 1947, the National Book Award in 1960, and many other honors. Books include *For the Union Dead* (1964).

MCCALL, JAMES EDWARD (1880–about 1950). Born in Alabama. Poet and newspaper editor who achieved success despite blindness resulting from typhoid fever.

MCKAY, CLAUDE (1890–1948). Born in Jamaica, moved to New York, later traveled in Europe and Africa. Wrote *Harlem Shadows* (1922), *Homage to Harlem* (1928), and other poetry.

MADGETT, NAOMI LONG (born 1923 in Virginia). Poet, college professor in Detroit, Michigan. Author of several books, including *Star by Star* (1965), *Exits and Entrances* (1978), and *Octavia and Other Poems* (1988).

MANDELA, NELSON (born 1918 in South Africa). He and his wife, Winnie, have been called "the first family of South Africa's freedom fight." He has written *No Easy Walk to Freedom* (1965), *The Struggle Is My Life* (1986), and other books.

MOUNT, WILLIAM SIDNEY (1807–1868). Born in New York. Painted many realistic scenes of everyday life on Long Island and elsewhere.

OWENS, JESSE (1913–1980). Born in Alabama. Legendary athlete who set three world records in one day (May 25, 1935) before going on to Olympic victories and other triumphs. Later became a successful business executive and author.

PAIGE, NATHANIEL. Courageous reporter who wrote eyewitness accounts of Civil War battles for the New York *Tribune*.

PEALE, RAPHAELLE (1774–1825). Born in Maryland. Achieved early success with portraits, later turned to still-life painting.

PICKETT, BILL (about 1862–1932). Probably born in Texas. Cowboy and movie star. First African American admitted to the National Rodeo Hall of Fame in Oklahoma City.

PIPPIN, HORACE (1888–1946). Born in Pennsylvania. Injured veteran who started painting at age forty-three; won many honors for his "primitive" pictures and sculpture.

PRENDERGAST, MAURICE BRAZIL (1859–1924). Born in Canada, this American artist is best known for his watercolor scenes of groups of people outdoors.

RAKIM. Contemporary "rap" performer who has recorded *Paid in Full* and other albums with his partner, **ERIC B.**

RANDALL, DUDLEY (born 1914 in Washington, D.C.). Poet, publisher, librarian. Books include *Cities Burning* (1968) and *Homage to Hoyt Fuller* (1984).

REYNEAU, BETSY GRAVES (1888–1964). Born in Michigan. Artist who painted portraits of prominent African Americans, including Mary McLeod Bethune, Charles Drew, Joe Louis, and Paul Robeson.

RIEFENSTAHL, LENI (born 1902 in Berlin). German photographer and filmmaker whose still pictures are prized for their feeling of vitality and action.

ROGERS, JOHN (1829–1904). Born in Massachusetts. Sculptor best known for "Rogers Groups" of literary or symbolic figures.

ROTHSTEIN, ARTHUR (1915–1985). Born in New York. Photographer who became well known for his candid pictures of people taken in the 1930s Depression.

SAINT-GAUDENS, AUGUSTUS (1848–1907). Very productive and well known American sculptor, born in Ireland, who took great pains with his larger public works to make them dramatic and moving.

SANCHEZ, SONIA (born 1934 in Alabama). Writer,

college professor; wrote *Homecoming* (1969) and *I've Been a Woman* (1978), among other books.

SCOTT, WILLIAM EDOUARD (1884–1964). Born in Indiana. Artist who won numerous prizes and awards for his paintings and murals.

SEARLES, CHARLES (born 1937 in Pennsylvania). American artist, strongly influenced by African travels, whose work appears in many art shows and collections.

SHAHN, BEN (1898–1969). Born in Lithuania. Artist who played an active part in politics; many of his works are concerned with social issues.

SPENCER, ANNE (1882–about 1960). Born in Virginia. Librarian and poet who wrote about the familiar things she loved.

STIEGLITZ, ALFRED (1864–1946). Born in New Jersey. Creative photographer who specialized in the buildings and people of New York.

TANNER, HENRY OSSAWA (1859–1937). Born in Pennsylvania. Artist who became famous in America and abroad, especially for his biblical paintings.

THOMAS, JOHN (1724–1776). Born in Massachusetts. General commanding the militia that forced the British to evacuate Boston during the American Revolution.

TOLSON, MELVIN B. (1900–1966). Born in Missouri. Poet whose books include *Rendezvous with America* (1944) and *Harlem Gallery* (1965).

TRUMAN, HARRY S (1884–1972). Born in Missouri. Thirty-third president of the United States (1945–53), who tried to pass civil rights legislation following the Second World War.

TRUMBULL, JOHN (1756–1843). Connecticut-born artist who fought in the American Revolution, later painted scenes of battle and triumph.

TWAIN, MARK (1835–1910). Born in Missouri as Samuel Clemens. Created *Tom Sawyer* (1876), *Huckleberry Finn* (1885), and other favorites.

WALKER, MARGARET (born 1915). Born in Alabama. Novelist, poet, college professor. Books include *For My People* (1942) and *Jubilee* (1966).

WASHINGTON, BOOKER T. (1856–1915). Born in Virginia. Famous educator who emphasized economic opportunity as the key to political and social equality.

WHEATLEY, PHILLIS (about 1753–1784). Born in Senegal, West Africa; brought to Boston as a slave; she gained freedom and fame as a poet there and in London.

WHITFIELD, JAMES M. (1823–1878). Born in New Hampshire. Poet who wanted to lead African Americans to a new life in Central America; wrote *America and Other Poems* (1853).

WHITMAN, WALT (1819–1892). Born in New York. Recognized as a major poet with *Leaves of Grass* (1855). Worked in Union hospitals during the Civil War, later wrote *Democratic Vistas* (1871) about America as he saw it.

WILDER, LAWRENCE DOUGLAS (born 1931 in Virginia). Military hero, lawyer, and legislator; elected governor of Virginia in 1989—the first African American to achieve such a position.

WILSON, HARRIET E. ADAMS (about 1827–1860). Probably born in New Hampshire. Author of *Our Nig; or Sketches from the Life of a Free Black, in a Two-Story White House, North, Showing that Slavery's Shadows Fall Even There* (1859), thought to be the first African-American novel published in the United States.

YARDE, RICHARD FOSTER (born 1939 in Massachusetts). Award-winning artist whose oil paintings and watercolors include some powerful portraits of African Americans.

LIST OF ILLUSTRATIONS

Pages 1 and 110: Jean Lacy. *Welcome to My Ghetto Land.* 1986. Paint, gesso, gold leaf on wood panel, 6 × 3″. Dallas Museum of Art, Metropolitan Life Foundation Purchase Grant (photo: Tom Jenkins). Page 2: Tony Duffy. *Hands of Florence Griffith Joyner Holding Her Four Olympic Medals.* 1988. Photograph (photo: ALLSPORT). Page 7: Jacob Lawrence. *On the Way.* 1990. Gouache on paper, 21 × 16″. Copyright Resident Associate Program, Smithsonian Institution, Washington, D.C. (photo: Chris Eden; courtesy Francine Seders Gallery, Seattle). Page 8: Jacob Lawrence. *Self-Portrait.* 1977. Watercolor and gouache on paper, 23 × 31″. National Academy of Design, New York. © 1991 VAGA. Page 9: Title page of *Poems on Various Subjects, Religious and Moral,* by Phillis Wheatley. 1773. Engraving. Page 10: John Singleton Copley. *Head of a Negro.* 1777–78. Oil on canvas, 21 × 16¼″. The Detroit Institute of Arts, Founders Society Purchase, Gibbs-Williams Fund. Page 12: John Hesselius. *Portrait of John Calvert and Negro Page.* 1761. Oil on canvas, 50¼ × 39⅞″. The Baltimore Museum of Art: Gift of Alfred R. and Henry G. Riggs, in Memory of General Lawrason Riggs. Page 13: John Singleton Copley. *Watson and the Shark.* 1778. Oil on canvas, 71¾ × 90½″. National Gallery of Art, Washington, D.C.; Ferdinand Lammot Belin Fund. Page 15: John Trumbull. *Lieutenant Grosvenor and Peter Salem* (detail from *The Battle of Bunker Hill*). 1786. Oil on canvas, 24 × 36″. Copyright Yale University Art Gallery (photo: Joseph Szaszfai). Page 17: Richard Yarde. *The Return.* 1976. Watercolor, 15½ × 20″. The Museum of Fine Arts, Boston; Sophie Friedman Fund. Page 18: *To Be Sold.* Public notice for a sale of slaves. 18th century. The Stratford Historical Society, Stratford, Conn. Page 19: *Benjamin Banneker,* on the title page of *Benjamin Bannaker's Pennsylvania, Delaware, Maryland and Virginia Almanac.* 1795. Woodcut engraving. Collection of the Maryland Historical Society. Page 20: Andrew Ellicott. *Pierre-Charles L'Enfant's Plan of Washington, D.C.* 1792. United States Geodetic Service. Page 21: Benjamin Henry Latrobe. *Thomas Jefferson.* c. 1799. Pencil sketch. Collection of the Maryland Historical Society. Page 23: *Signers of the Petition to the Congress of the United States, Dec. 30, 1799* (detail). National Archives, Washington, D.C. Page 24: Raphaelle Peale. *Absalom Jones.* 1810. Oil on paper, mounted on board, 30 × 25″. Delaware Art Museum, Wilmington; Gift of Absalom Jones School, Wilmington. Page 26: Cover of *Thanksgiving Sermon on Account of the Abolition of the African Slave Trade.* 1808. The Historical Society of Pennsylvania. Page 27: J. W. Hurn. *Frederick Douglass.* N.d. Photograph. From the Collections of the Library of Congress. Page 29: Nathaniel Jocelyn. *Cinque.* 1839. Oil on canvas, 30¼ × 25½″. New Haven Colony Historical Society, Gift of Dr. Charles Purvis, 1898 (photo: William K. Sacco, 1990). Page 30: *Gravestones of Amos and Violate Fortune, Former Slaves.* Early 19th century. National Museum of American History, Smithsonian Institution, Washington, D.C. Page 31: *Iron Man.* c. 1800. Wrought iron, height 14″. Collection Adele Earnest. Page 32: *The Old Plantation.* 1790–1800. Watercolor on laid paper, 11¹¹⁄₁₆ × 17⅞″. Abby Aldrich Rockefeller Folk Art Center, Williamsburg, Va. Page 33: Henry Ossawa Tanner. *The Banjo Lesson.* 1893. Oil on canvas, 48 × 35″. Hampton University Museum, Hampton, Va. Page 34: Thomas Eakins. *The Banjo Player,* study for *Negro Boy Dancing.* c. 1878. Oil on canvas, 20 × 15¼″. National Gallery of Art, Washington, D.C.; Collection of Mr. and Mrs. Paul Mellon. Page 35: Eastman Johnson. *Life in the Old South (Old Kentucky Home).* 1859. Oil on canvas, 36 × 45¼″. Courtesy of the New-York Historical Society, New York City. Page 36: McCrary & Bronson. *Happy John.* 1897. Photograph. From the Collections of the Library of Congress. Page 37: Joel Axel-rad. *Jimi Hendrix.* Photograph (photo: MICHAEL OCHS ARCHIVES/Venice, Calif.). Page 38: William Sidney Mount. *Eel Spearing at Setauket.* 1845. Oil on canvas, 29 × 36″. New York State Historical Association, Cooperstown. Page 39: *Flora.* Bill of sale. 1796. Cut-paper silhouette, brown ink. The Stratford Historical Society, Stratford, Conn. Page 40: John Rogers. *Slave Auction.* 1859. Plaster, 7 × 13¼″. New Canaan Historical Society; John Rogers Collection. Page 42: Eastman Johnson. *The Ride for Liberty—The Fugitive Slaves.* c. 1862. Oil on board, 22 × 26¼″. The Brooklyn Museum; Gift of Miss Gwendolyn O. L. Conkling. Page 44: Augustus Saint-Gaudens. *Head of a Young Man,* study for *The Robert Gould Shaw Memorial.* c. 1884–87. Bronze with marble base, height 7½″. Courtesy of U.S. Department of Interior, National Park Service, Saint-Gaudens National Historic Site, Cornish, N.H. (photo: © 1990 Jeffrey Nintzel, All Rights Reserved). Page 46: Augustus Saint-Gaudens. *The Robert Gould Shaw Memorial.* 1884–97. Bronze relief (photo: Richard Benson). Page 47: William E. Scott. *Booker T. Washington.* 1916. Oil on canvas, 36 × 26⅛″. George Washington Carver Museum, Tuskegee Institute National Historic Site, National Park Service (photo: Robert Fouts). Page 49: Benin culture (Nigeria). *Warrior and Attendants.* 17th century. Bronze plaque, 14¾ × 15½″. The Nelson-Atkins Museum of Art, Kansas City, Missouri (Nelson Fund) 58-3. Page 50: *Man with Grapes.* c. 1875. Painted wood, height 15″. Guennol Collection. Page 51: Alexander Gardner. *Abraham Lincoln.* April 10, 1865. Silver-albumen print, 17¹¹⁄₁₆ × 14⅛″. National Portrait Gallery, Smithsonian Institution, Washington, D.C. Page 52: John George Brown. *The Longshoreman's Noon.* 1879. Oil on canvas, 33¼ × 50¼″. In the Collection of The Corcoran Gallery of Art, Museum Purchase. Page 53: Winslow Homer. *The Watermelon Boys.* 1876. Oil on canvas, 24⅛ × 38⅛″. Courtesy of the Cooper-Hewitt Museum, Smithsonian Institution; Gift of Charles Savage Homer, 1917 (photo: Art Resource, New York). Page 54: Lewis W. Hine. *Carolina Cotton Mill.* 1908. Gelatin-silver print on Masonite, 10½ × 13½″. Collection, The Museum of Modern Art, New York. Purchase. Page 57: Edgar Degas. *The Cotton Market at New Orleans* (or *Portraits in an Office*). 1873. Oil on canvas, 29⅛ × 36¼″. Musée des Beaux Arts. Pau, France. Page 58: *Loading Cotton on the Mississippi.* 1906. Photograph. From the Collections of the Library of Congress. Page 60: Charles Dana Gibson. *A Daughter of the South.* 1909. Ink on paper. From the Collections of the Library of Congress. Page 61: John Henry Adams, Jr. *The New Negro Woman.* 1904. Drawing for "Rough Sketches: A Study of the Features of the New Negro Woman" for *Voice of the Negro,* August 1904. Moorland-Spingarn Research Center, Howard University. Page 64: Maurice Brazil Prendergast. *West Church, Boston* (or *West Church at Cambridge and Lynde Streets* or *Red School House, Boston*). c. 1901. Watercolor, graphite and opaque on white paper, 10⅞ × 15⅜″. Courtesy, The Museum of Fine Arts, Boston; Charles Henry Hayden Fund. Page 65: Frances Benjamin Johnston. *Children in Alabama.* c. 1895. Photograph. From the Collections of the Library of Congress. Page 66: Thomas Hart Benton. *Planting (Spring Plowing).* 1939. Lithograph on paper, 9⅞ × 12¹¹⁄₁₆″. National Museum of American Art, Smithsonian Institution, Washington, D.C. (photo: Art Resource, New York). Page 67: Sargent Claude Johnson. *Forever Free.* 1933. Wood with lacquer on cloth, 36 × 11½ × 9½″. San Francisco Museum of Modern Art. Gift of Mrs. E. D. Lederman. Page 68: Robert Gwathmey. *Portrait of a Farmer's Wife.* 1951. Oil on canvas, 44¼ × 34″. Hirshhorn Museum and Sculpture Garden, Smithsonian Institution, Gift of The Joseph H. Hirshhorn Foundation, 1966. © 1991 VAGA (photo: John Tennant).

Page 69: Arthur Rothstein. *Girl at Gee's Bend, Alabama*. 1937. Photograph. From the Collections of the Library of Congress. Page 71: George Wesley Bellows. *Both Members of This Club*. 1909. Oil on canvas, 35½ × 46¼″. National Gallery of Art, Washington, D.C., Chester Dale Collection. Page 72: William H. Johnson. *Chain Gang*. 1939–40. Oil on fiberboard, 45½ × 38⅛″. National Museum of American Art, Smithsonian Institution, Washington, D.C. (photo: Art Resource, New York). Page 73: Palmer Hayden. *John Henry on the Right, Steam Drill on the Left*. 1944–54. Oil on canvas, 30 × 40″. Collection of The Museum of African American Art, Los Angeles; Palmer C. Hayden Collection, Gift of Miriam A. Hayden (photo: The Studio Museum in Harlem, Armando Solis). Page 74: Betsy Graves Reyneau. *George Washington Carver, Scientist*. 1942. Oil on canvas, 44¼ × 35″. National Portrait Gallery, Smithsonian Institution; Transfer from the National Museum of American Art; Gift of the George Washington Carver Memorial Committee to the Smithsonian Institution, 1944. Page 76: Ben Shahn. *Welders*. 1943. Tempera on cardboard on composition board, 22 × 39¾″. Collection, The Museum of Modern Art, New York. Purchase. Page 77: *Bill Pickett in "The Bull-Dogger."* 1923. Lithograph, 41 × 27″. From the Poster Collection, Library of Congress. Page 78: *Mulberry Street, New York*. 1906. Photograph. From the Collections of the Library of Congress. Page 80: Alfred Stieglitz. *The City of Ambition*. c. 1909–10. Photograph. From the Collections of the Library of Congress. Page 82: Meta Warwick Fuller. *Ethiopia Awakening*. 1914. Plaster, height 14″. Museum of the National Center of Afro-American Artists. Page 84: Ernest Lawson. *Spring Night, Harlem River*. 1913. Oil on canvas, 25⅛ × 30⅛″. © The Phillips Collection, Washington, D.C. Page 87: *Lorraine Hansberry*. c. 1960. Photograph. Schomburg Center for Research in Black Culture, The New York Public Library, Astor, Lenox and Tilden Foundations. Page 89: Romare Bearden. *Patchwork Quilt*. 1970. Cut-and-pasted paper with synthetic polymer paint on composition board, 35¾ × 47⅞″. Collection, The Museum of Modern Art, New York. Blanchette Rockefeller Fund. Page 90: Russell Lee. *Negro Boys on Easter Morning on the South Side of Chicago*. April 1941. Photograph. From the Collections of the Library of Congress. Page 92: James Chapin. *Ruby Green Singing*. 1928. Oil on canvas, 38 × 30″. Norton Gallery, School of Art, West Palm Beach, Fla. Page 93: Horace Pippin. *Holy Mountain III*. 1945. Oil on canvas, 25¼ × 30¼″. Hirshhorn Museum and Sculpture Garden, Smithsonian Institution, Gift of Jo-

seph H. Hirshhorn, 1966. Page 94: Jurgen Schadeberg. *Nelson Mandela in Johannesburg, South Africa*. 1952. Photograph. Chancellor House, Fox Street, Johannesburg (photo: Bailey's African Photo Archive). Page 95 left: D. D. Galyeau. *Governor Lawrence Douglas Wilder of Virginia*. c. 1988. Photograph (photo: Courtesy of the Virginia Polytechnic Institute). Page 95 right: Michael Ochs. *Jesse Jackson*. c. 1970. Photograph (photo: MICHAEL OCHS ARCHIVES/ Venice, Calif.). Page 96: Leni Riefenstahl. *Jesse Owens in the Olympic Games*. 1936. Photograph (photo: Bildarchiv Preussischer Kulturbesitz). Page 97: Jacob Lawrence. *Munich Olympic Games (Study for the Munich Olympic Games Poster)*. 1971. Gouache on paper, 35½ × 27″. The Seattle Art Museum, purchased with funds from PONCHO. © 1991 VAGA (photo: Paul Macapia). Page 100: Neil Leifer. *Florence Griffith Joyner Winning a Gold Medal at the 1988 Olympics*. 1988. Photograph. Page 101: Fred Ward. *The March on Washington*. August 28, 1963. Photograph (photo: Fred Ward/Black Star). Page 102: Flip Schulke. *Martin Luther King, Jr., with His Son*. c. 1963. Photograph (photo: Flip Schulke/Black Star). Page 103: Bob Adelman. *Martin Luther King, Jr., Giving His "I Have a Dream" Speech*. August 28, 1963. Photograph (photo: © Bob Adelman 1979, MAGNUM PHOTOS, INC.). Page 104: *Freedom Riders (John Lewis and Jim Swerg)*. 1961. Photograph (photo: UPI/BETTMANN). Page 105: James Karales. *Civil Rights March from Selma to Montgomery, Alabama*. March 21, 1965. Photograph. Page 107: *Martin Luther King, Jr., in a Jefferson County Courthouse Jail Cell, Birmingham, Alabama*. 1967. Photograph (photo: UPI/BETTMANN). Page 108: Cesar Vern. *Rappers: Eric B. and Rakim*. 1989. Photograph (photo: Courtesy MCA Records). Page 109: Charles Searles. *Feles for Sale*. 1972. Acrylic on canvas. Museum of the National Center of Afro-American Artists. Page 110: *See* credit for Page 1. Page 112: Jacob Lawrence. *Vaudeville*. 1951. Tempera on gesso, 30 × 20″. Hirshhorn Museum and Sculpture Garden, Smithsonian Institution, Gift of Joseph H. Hirshhorn, 1966. © 1991 VAGA. Page 114: James Leonard. *Wind Machine with Gabriel, Eleanor Roosevelt, and Louis Armstrong*. 1984. Cut and soldered copper with liver of sulfate markings on wood base, 28 × 18½ × 10″. National Museum of American Art, Smithsonian Institution, Washington, D.C.; Gift of Herbert Waide Hemphill, Jr. (photo: Art Resource, New York). Page 115: George Kruse. *A Girl Urges Her Friends to Help "Stop the Death of a Race."* 1989. Photograph.

ACKNOWLEDGMENTS

Grateful acknowledgment is made for permission to reproduce the poems, songs, and text excerpts by the following writers. All possible care has been taken to trace ownership of every selection included and to make full acknowledgment. If any errors or omissions have occurred, they will be corrected in subsequent editions, provided that notification is sent to the publisher.

Anonymous, "A Long Time Ago," folk song, Library of Congress AFS L27, "American Sea Songs and Shanties," edited by Duncan Emrich. Anonymous, "Black-Eyed Susie," folk song, Library of Congress AFS 3114:B3. Anonymous, "Roll the Cotton Down," folk song, Library of Congress AFS L27, "American Sea Songs and Shanties," edited by Duncan Emrich. James Baldwin, "Harlem—Then and Now." Published in F. M. Eckman's *The Furious Passage of James Baldwin*. Reprinted by arrangement with The James Baldwin Estate. Imamu Amiri Baraka (LeRoi Jones), "Ka 'Ba," from *The Dead Lecturer*. Reprinted by permission of Sterling Lord Literistics, Inc. Copyright © 1990 by Amiri Baraka (LeRoi Jones). Imamu Amiri Baraka (LeRoi Jones), "Return of the Native," from *Black Poetry 1961–1967*. Reprinted by permission of Sterling Lord Literistics, Inc. Copyright © 1990 by Amiri Baraka. Imamu Amiri Baraka (LeRoi Jones), "Young Soul," from *Black Poetry 1961–1967*, published by Bobbs-Merrill Company. Reprinted by permission of Sterling Lord Literistics, Inc. Copyright © 1990 by Amiri Baraka. Arna Bontemps, "Nocturne of the Wharves." Reprinted by permission of Harold Ober Associates Incorporated. Copyright © 1963 by Arna Bontemps. Arna Bontemps, "Southern Mansion." Reprinted by permission of Harold Ober Associates Incorporated. Copyright © 1963 by Arna Bontemps. Sharon Bourke, "People of Gleaming Cities, and of the Lion's and the Leopard's Brood," from *Understanding the New Black Poetry*, ed. Stephen Henderson. Gwendolyn Brooks, "Building," from *The Near-Johannesburg Boy*. Gwendolyn Brooks: The David Company, Chicago. Copyright, 1987. Gwendolyn Brooks, "Old Mary," from *Blacks* by Gwendolyn Brooks. Published by The David Company, Chicago. Copyright, 1987. Gwendolyn Brooks, "Strong Men, Riding Horses," from *Blacks* by Gwendolyn Brooks. Published by The David Company, Chicago. Copyright, 1987. Gwendolyn Brooks, "To the Young Who Want to Die," from *The Near-Johannesburg Boy*. Gwendolyn Brooks: The David Company, Chicago. Copyright, 1987. Gwendolyn Brooks, "To Those of My Sisters Who Kept Their Naturals," from *The Near-Johannesburg Boy*. Gwendolyn Brooks: The David Company, Chicago. Copyright, 1987. Gwendolyn Brooks, "The White Troops Had Their Orders But the Negroes Looked Like Men," from *Blacks* by Gwendolyn Brooks. Published by The David Company, Chicago. Copyright, 1987. Sterling A. Brown, "Southern Road" and "Strong Men." Permission for use of works in the Estate of Sterling Brown has been granted by John L. Dennis. Richard Bruce, "Shadow," from *Opportunity: A Journal of Negro Life*, reprinted in *Caroling Dusk: An Anthology of Verse by Negro Poets*. Lucille Clifton, "Love Rejected," from *Good Times*. Copyright © 1969 by Lucille Clifton. Reprinted by permission of Random House, Inc. Countee Cullen, "Heritage," reprinted by permission of GRM Associates, Inc., Agents for the Estate of Ida M. Cullen from the book *On These I Stand* by Countee Cullen. Copyright © 1925 by Harper Brothers; copyright renewed 1953 by Ida M. Cullen. Margaret Danner, "The Slave and the Iron Lace," from *The Down of the Thistle* by Margaret Danner, published by Country Beautiful, 1976. Used by permission of The Estate of Margaret Danner. Bob Dylan, excerpt from "Blowin' in the Wind,"

song lyrics from album *The Freewheelin' Bob Dylan*. Copyright © 1962 WARNER BROS. MUSIC; copyright renewed 1990, Bob Dylan. This arrangement copyright 1992, Special Rider Music. All rights reserved. International copyright secured. Used by permission. Mari Evans, "Marrow of My Bone," "Spectrum," and "Where Have You Gone," from *I Am a Black Woman*, published by William Morrow & Company, 1970, by permission of the author. Rudolph Fisher, "This Mus' Be Harlem," excerpt from "Miss Cynthie," from *On Being Black*. Betty Gates, "Mamma Settles the Dropout Problem," from *Understanding the New Black Poetry* by Stephen Henderson. Nikki Giovanni, "The Funeral of Martin Luther King, Jr.," from *Black Feeling, Black Talk, Black Judgment*, by Nikki Giovanni. Copyright © 1968, 1970 by Nikki Giovanni; by permission of William Morrow & Co., Inc. Oscar Hammerstein II, "Ol' Man River," song lyrics from *Show Boat*. Music by Jerome Kern and lyrics by Oscar Hammerstein II. Copyright © 1927 PolyGram International Publishing, Inc. Copyright renewed. International Copyright Secured. All rights reserved. Used by permission. Lorraine Hansberry, "I Want So Many Things," excerpt from *A Raisin in the Sun*. Copyright © 1958 by Robert Nemiroff, as an unpublished work. Copyright © 1959, 1966, 1984 by Robert Nemiroff. Reprinted by permission of Random House, Inc. Robert Hayden, "Frederick Douglass," "Runagate Runagate," and " 'Summertime and the Living...,' " reprinted from *Collected Poems of Robert Hayden*, edited by Frederick Glaysher, by permission of Liveright Publishing Corporation. Copyright © 1985 by Erma Hayden. Frank Horne, "Dig Your Starting Holes Deep and Firm," excerpt from "To James," in *In Haverstraw* (London, Paul Bremàn Ltd, 1963). Langston Hughes, "Children's Rhymes." Copyright 1951 by Langston Hughes. Reprinted from *The Panther and the Lash* by Langston Hughes, by permission of Alfred A. Knopf, Inc. Langston Hughes, "Daybreak in Alabama," from *Selected Poems*, Copyright 1948 by Alfred A. Knopf, Inc., and renewed 1976 by the Executor of the Estate of Langston Hughes. Langston Hughes, "Laughers," from *The Weary Blues*. Reprinted by permission of Harold Ober Associates Incorporated. Copyright 1927 by Alfred A. Knopf, Inc. Copyright renewed 1955 by Langston Hughes. Langston Hughes, "Minstrel Man," from *The Dream Keeper and Other Poems* by Langston Hughes. Copyright 1932 by Alfred A. Knopf, Inc., and renewed 1960 by Langston Hughes. Reprinted by permission of the publisher. Langston Hughes, "Mother To Son," from *Selected Poems*, Copyright 1926 by Alfred A. Knopf, Inc., and renewed 1954 by Langston Hughes. Langston Hughes, "The Negro Speaks of Rivers," from *Selected Poems*, Copyright 1926 by Alfred A. Knopf, Inc., and renewed 1954 by Langston Hughes. Langston Hughes, "Question and Answer," from *The Panther and the Lash*. Copyright © 1967 by Langston Hughes. Reprinted by permission of Alfred A. Knopf, Inc. Langston Hughes, "Song for a Banjo Dance," Copyright 1926 by Alfred A. Knopf, Inc., and renewed 1954 by Langston Hughes. Reprinted from *The Weary Blues* by Langston Hughes, by permission of the publisher. Langston Hughes, "Temple for Tomorrow," excerpt from "The Negro Artist and the Racial Mountain," *The Nation*, Vol CXXII (June 23, 1926), page 694. Isaac, "Old Master Jefferson," excerpt from *Memoirs of a Monticello Slave, 1847*, from *Jefferson at Monticello*, pp. 13–14, ed. James A. Bear, Jr. University Press of Virginia. James Weldon Johnson, "Listen, Lord—A Prayer," from *God's Trombones* by James Weldon Johnson. Copyright 1927 by The Viking Press, Inc., copyright renewed © 1955 by Grace Nail Johnson. Reprinted by permission of the publisher, Viking Penguin, a division of Penguin Books USA Inc. James Weldon Johnson,

POETRY TITLE AND AUTHOR INDEX